IMAGES
of America

AMANA COLONIES
1932–1945

ON THE COVER: During Amana's communal era (1855–1932), at least three cobbler shops operated in the seven villages, producing shoes from leather. By 1937, when William Noé photographed Middle Amana cobbler Carl Hergert (1883–1972), Hergert mainly repaired shoes bought from outside suppliers. Hergert continued to repair shoes until he closed his shop in 1950. His equipment, including the stool and work bench pictured here, is displayed at the Amana Heritage Museum. (Author's collection.)

IMAGES
of America
AMANA COLONIES
1932–1945

Peter Hoehnle

ARCADIA
PUBLISHING

Published by Arcadia Publishing
Charleston, South Carolina

Printed in the United States of America

Library of Congress Control Number: 2015946151

For all general information, please contact Arcadia Publishing:
Telephone 843-853-2070
Fax 843-853-0044
E-mail sales@arcadiapublishing.com
For customer service and orders:
Toll-Free 1-888-313-2665

Visit us on the Internet at www.arcadiapublishing.com

In memory of Ivan W. Reihmann, who was the first baby born in Amana after the Great Change, grew up during the period covered in this book, and, as a business leader, church elder, translator, performer, friend, and neighbor, did much for the Amana community that he loved.

CONTENTS

ACKNOWLEDGMENTS

This book would not have been possible without the assistance of executive director Lanny Haldy and curator Kelly Oates of the Amana Heritage Society, who facilitated use of the society's massive collection of original images and negatives.

Heritage society volunteer Larry Ertz spent countless hours patiently producing high-quality digital images from the original negatives of John W. Barry, William Noé, and Rudolph Kellenberger in the heritage society collection. These images, and this work in general, have benefitted from his technical expertise and careful eye and attention to detail.

Many individuals assisted with identifying scenes and people in different photographs. Their help was invaluable. Among those who assisted were William Ackerman, Madeline Roemig Bendorf, Phillip Birk, Erna Fels, Joyce Fels, Betty Graesser, Charles and Barbara Hoehnle, Elly and Rose Hoehnle, Emilie Hoppe, Lucille Kraus, William Leichsenring Jr., Rose Leonhardt, Betty Lippman, Rosemarie McGowan, Gary Mittelbach, Wilma Neuman, Catherine Oehl, Shirley Reihman, Clarence and Esther Lou Reihman, Ivan Reihmann, Isabella Schaefer, Kirby Schaefer, Norman Schanz, Linda Schuerer, Mildred Setzer, Mike Shoup, Caroline Trumpold, Dorothy Trumpold, Marlene Trumpold, Deborah Weiskopf, Guy Wendler, Scott Williams, and Cornelia Zuber.

Special thanks to Jesse Darland and the staff at Arcadia for their guidance and support throughout this project.

Unless otherwise noted, all images appear courtesy of the Amana Heritage Society.

INTRODUCTION

The Amana Society originated as a Pietist religious sect in southwestern Germany in 1714. Founded by Eberhard Ludwig Gruber (1665–1728) and Johann Friedrich Rock (1678–1749), the sect was known as the Community of True Inspiration because its members believed that God still communicated his will directly to his people through certain pious and specifically gifted *Werkzeuge*, or instruments. Scribes followed these instruments and recorded revelations as they were spoken. Typically, revelations were admonitions toward greater piety and faithfulness among believers; sometimes they chastised an individual for transgressions, and sometimes testimonies were prayers or short sermonettes focusing on a particular passage of scripture.

Like many other Pietists, the Inspirationists were pacifists, did not believe in swearing legal oaths, and dressed and lived plainly. Through the almost constant travels of its chief Werkzeug, J.F. Rock, the sect eventually had over 90 small congregations scattered through southern Germany, Alsace, Switzerland, and Saxony. With Rock's death in 1749, the sect was left without an inspired leader, although his former scribe Paul Nagel and other associates provided stable leadership, which allowed the sect to survive without a charismatic leader.

By 1817, however, the sect was in serious decline when a new Werkzeug, Michael Kraussert (c. 1788–?) emerged. He was soon joined by Barbara Heinemann (1795–1883) and finally, by Christian Metz (1793–1867). Kraussert fell into disrepute and left the sect, and Heinemann ceased to deliver revelations following her marriage, leaving Christian Metz as the sect's primary leader by 1823. Metz traveled throughout the German territories visiting and reviving Inspirationist congregations.

Beginning in 1826, as political and religious tensions made it difficult for Inspirationists to remain in particular areas, Metz began to lease large estates in the region of Hessen Darmstadt as refuges for the faithful. Approximately 400 of the faithful eventually congregated on the estates.

In 1842, Metz delivered a testimony that instructed the Inspirationists to immigrate to the United States. Later that fall, Metz and three associates traveled to New York state and eventually located and began the purchase of a 5,000-acre tract of land on the Buffalo Creek Indian Reservation near Buffalo, New York. Beginning in 1843, the faithful departed for the United States, with 800 having arrived at the site named Eben-Ezer by 1846. Eventually, continued immigration would swell the six small villages established on land in New York and later on two tracts in Canada to over 1,200 people.

The community adopted a communal form of living as a temporary measure to enable it to become established. In 1846, the society adopted a constitution making communal living permanent. Under this system, land, shops, factories, and houses were community property, church elders assigned workers jobs on the farms or in the factories and craft shops, and members ate together in assigned communal kitchens and dining halls.

The Eben-Ezer Society, as it was known, prospered. The growing city of Buffalo, the increasing cost of land, and continued emigration, however, put tremendous pressure on the society. In

1854, Metz again declared that the time had come to relocate. After an abortive attempt to find a suitable location in Kansas, a committee located a site in Iowa. In June 1855, a third committee began purchasing what eventually totaled 26,000 acres of land along the Iowa River in east central Iowa.

The new settlement was named Amana, a biblical term meaning "remain true," and received a charter as the Amana Society in 1859. Over a 10-year period, the society sold its property in New York and completely relocated to Iowa. Here, the members of the society created seven villages, each approximately an hour apart by oxcart and in the middle of its own farm: Amana (or Main Amana), East Amana, High Amana, Middle Amana, South Amana, West Amana, and Homestead. In the larger villages of Amana and Middle Amana, the society started factories, including two woolen mills and a calico print mill to produce cloth for the society and external sale.

Members above the age of 14 received assignments to work in the factories, on the farms, or in one of the many craft shops that were to be found in each village, including blacksmiths, wagon makers, carpenters, tinsmiths, broom makers, bakeries, dairies, a tannery, and flour mills. Women worked in one of the more than 50 communal kitchens in the seven villages, with each kitchen house under the direction of a manager or kitchen boss and preparing food for approximately 35 to 40 people. Mothers remained at home following the birth of children and then returned to work when the child was three and old enough to enter the village *Kinderschule*. From the ages of five to 14, children attended the school in their village.

Each evening, members of the society attended an evening prayer service; additional services on Wednesdays, Saturdays, and Sundays brought the total religious services each week to 11. Lay elders conducted the services, which included a cappella singing, readings from the testimonies of the early leaders, scripture readings, prayer, and commentaries by the elders.

Authority was vested in a governing board of 13 trustees elected each December from among the elders. Each village had one trustee with the six additional members allocated to each village according to its population. The trustees chose a president from their members. During the lifetimes of the last two Werkzeuge, Christian Metz and Barbara Heinemann, ultimate spiritual authority rested in them, although in business and social matters the trustees appear to have always held ultimate authority.

In 1881, the society achieved its highest population—1,813 members. By the turn of the 20th century, the Amana Society was the largest communal society in the United States.

By the 1920s, serious cracks were apparent in the formidable communal structure. Over time, younger members of the society, frustrated at a lack of educational and work opportunities, left for the outside world. Visitors arriving by train, and after the 1910s, by automobile, exposed members to the fashions and customs of the outside world. Some members feigned illness in order to avoid work, and the society paid the salaries of an ever-increasing army of hired workers in order to fill the labor void created. Economic problems, including a drastic decline in textile sales, a fire that destroyed the Amana woolen mill, and a decrease in farm income following World War I, further weakened the financial structure of the society.

In the late 1920s, a cadre of concerned members of the society lobbied the trustees to address these concerns from a fear that the society was faced with inevitable bankruptcy, receivership, and dissolution. In April 1931, the board authorized the election of a committee of representatives to plan for the future of the society. This group, known as the Committee of Forty-Seven, submitted a questionnaire to the members asking if they favored a return to a more stringent communal way or reorganizing. The vast majority indicated support for reorganization, and ultimately the committee developed a plan whereby the business and farming interests of the Amana Society were separated into a separate for-profit business corporation while the religious aspects were placed in the hands of a separate Amana Church Society. Approved by the vote of its members, the new plan officially took effect on June 1, 1932, and communal living was abandoned. The story of what happened next is told in these pages.

Throughout its years as a communal society, Amana was always unique, and its transition from communal living to modern American society was no less singular. Fortunately, the scenes of those years of change were documented by a variety of Amana and Iowa photographers whose work illustrates these pages.

Two Amana natives, William Noé (1898–1978) and Rudolph Kellenberger (1907–1996), were avid photographers. Kellenberger used a simple Kodak Brownie to capture scenes of community life. William Noé was a more technical photographer who not only documented Amana scenes but made formal portraits of his neighbors and photographed Amana workers, scenes, and products for use in the society's advertising.

Excellent published collections of Amana photographs taken before the 1932 reorganization, including *The Amanas Yesterday* by Joan Liffring-Zug Bourret and *Picturing Utopia: Bertha Shambaugh and the Amana Photographers* by Abigail Foerstner, exist. Bourret, a noted Iowa photographer, has chronicled the Amanas since 1959, and her Amana images appear in a number of periodicals and books, most notably *The Amanas: A Photographic Journey, 1959–1999*. The period covered by this book falls between the eras covered by the work of Foerstner and Bourret, and it is meant to bridge the two periods of community history that they cover.

The Amana Society had been a popular destination for descriptive writers and the occasional photographer since the late 19th century. In the years following the transition from communal living, however, the work of regional professional John W. Barry (1905–1988) is the most striking. A lifelong resident of Cedar Rapids, Barry brought his camera to the colonies in July and August 1937 to document Amana scenes and people for a project with his friend, writer Paul Engle (1908–1991). Engle, also a Cedar Rapids native, was a Rhodes scholar who had already achieved national recognition for his poetry. In 1941, he became director of the Iowa Writer's Workshop and during 20 years at its helm developed it into one of the leading writing programs in the United States.

Engle and Barry's intent was to create a photographic essay to sell to *Life* magazine. They visited the Amana villages several times to take photographs, with Engle assisting Barry and performing chores, such as holding lights. Although Barry completed his work, Engle never wrote the essay. The Amana Society purchased some of Barry's images for use in its advertising, however, and Barry also sold use of individual images to the *Cedar Rapids Gazette* and other publications. Barry's photographs have continued to appear as illustrations through the years.

Barry's daughter Shearon Barry Elderkin donated his carefully preserved collection of 87 negatives to the Amana Heritage Society in 1992. The heritage society also holds the negatives of both William Noé and Rudolph Kellenberger. When possible, images from these three photographers used in this work have been copied from the original negatives.

Information for the text has been drawn from a variety of primary and secondary sources. The *Amana Society Bulletin* and the writings of author Bertha M.H. Shambaugh and graduate student Richard H. Roberts of the University of Iowa provided interesting personal perspectives on changes in Amana as they observed them in the 1930s.

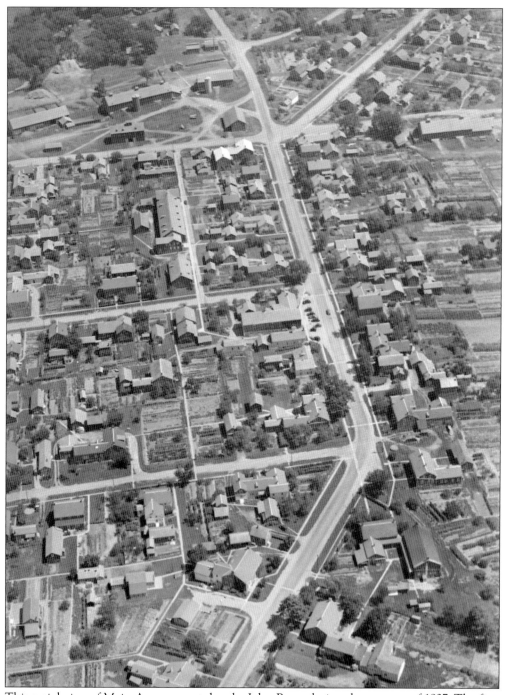

This aerial view of Main Amana was taken by John Barry during the summer of 1937. The first aerial view of this village had been taken by a photographer for the *Des Moines Register and Tribune* in 1921.

One

THE GREAT CHANGE

Planning for the reorganization of the Amana Society, an event known locally as the Great Change, began with the election of the Committee of Forty-Seven by the society's membership in April 1931. The committee distributed a questionnaire to gauge community support either for returning to a stricter communal lifestyle or reorganizing. An overwhelming 74 percent of those responding supported reorganization, providing the committee a mandate for its work.

With the assistance of attorneys, the committee crafted a reorganization plan, creating a new Amana Society corporation to operate the industries, shops, and farms of the old society. The plan was approved by a 96 percent vote of the society membership on February 2, 1932. Adult members received a share of stock that entitled them to voting privileges in society elections and medical and burial benefits. Members also received prior distributive shares, with a par value of $60, for each year they had worked under the communal system, with the idea that older members unable to work for wages would redeem these shares for living expenses.

During April 1932, all of the communal kitchen houses closed, and members created makeshift kitchens in their homes. On May 2, the corporate offices opened, and the society began paying a uniform hourly 10¢ wage to employees. On June 1, 1932, the official transfer of property from the old to the new Amana Society occurred, and the fourth longest-lived communal society in the United States passed from existence.

In truth, the period from the Great Change to the end of World War II was one of almost constant change for the people of Amana. During this time, they not only reorganized their economic system but also adjusted their religious, social, and home lives to that of modern 20th-century America, which, through 15 years of depression and war, was experiencing startling changes of its own.

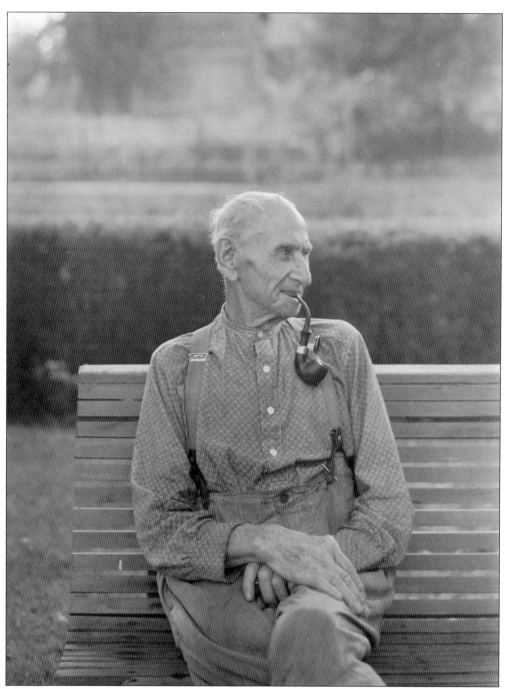

John Barry photographed broom maker Jakob Murbach (1855–1940), seated on a typical wooden Amana garden bench, in August 1937. Murbach wears a calico work shirt typical of the communal era. A note by Barry preserves a snatch of conversation between photographer and subject, in which Murbach joked, "My father was always a sickly man—he only lived to be 80 years old." Murbach was born in Upper Eben-Ezer, New York. At his death, he was one of the last people who had lived in the Eben-Ezer villages.

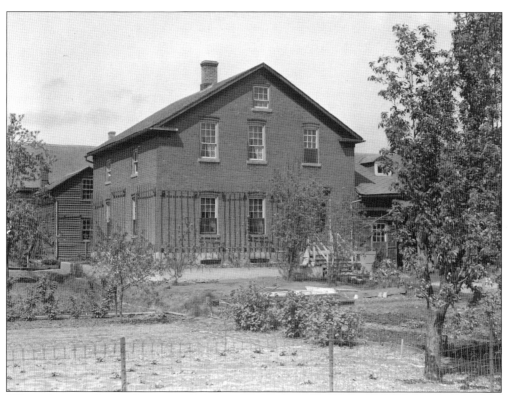

When photographed by Barry in 1937, this 1870 brick house in Main Amana was home to the Conrad Baust family. Approximately a decade before Barry's photograph, this house was also the subject of an oil sketch by his friend and frequent Amana visitor Grant Wood (1891–1942).

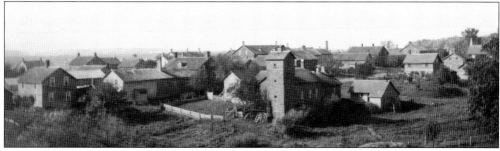

Rudolph Kellenberger (1907–1996) took this idyllic view of his home village of West Amana from a hill north of the community. The smoke tower of the West Amana Meat Market is at center.

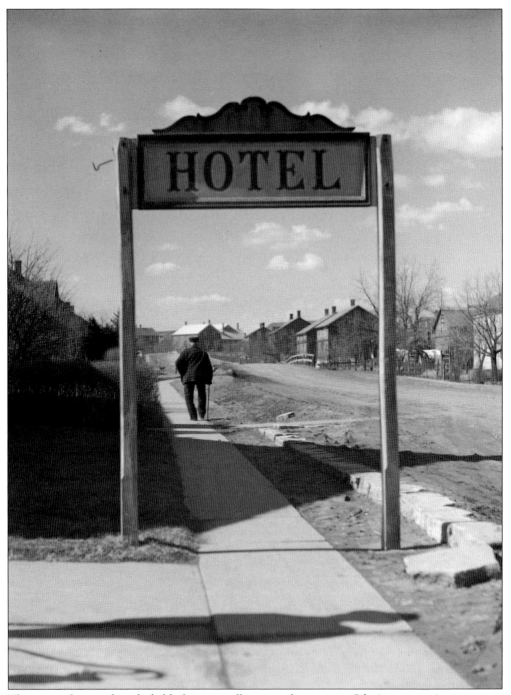

This view of an unidentified elderly man walking up what is now 47th Avenue in Amana was a favorite of photographer John Barry and served as the cover image for the small portfolio of 13 of his Amana images, *The People of Amana*, produced in 1975.

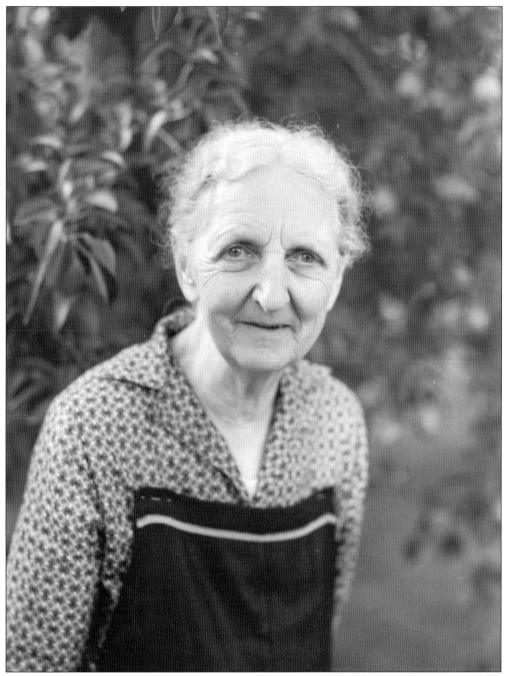

Louise Jeck (1864–1952) was a lifelong member of the society and a relative, by marriage, to John Barry's friend Paul Engle. Engle's maternal great-uncle had married Jeck's sister. Engle knew her as Tante Louise (Aunt Louise), and wrote tenderly of his family's visits with her. Orphaned at the age of four, Jeck was raised by her grandmother, educated in Amana, and spent most of her life working in the communal kitchens of her home village.

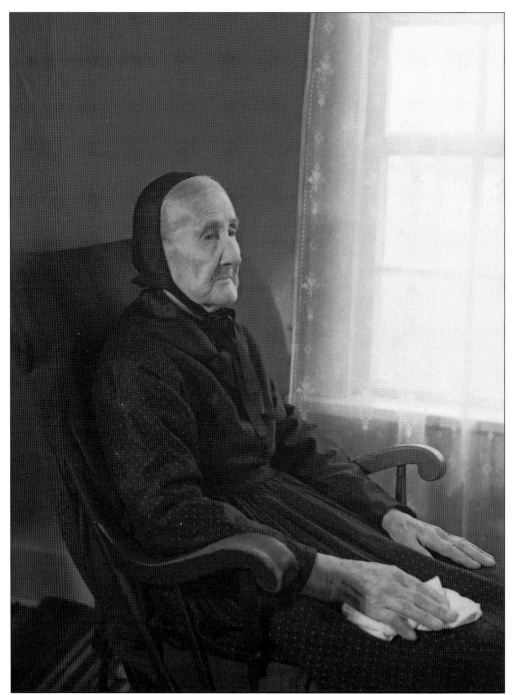

Catherine Bender Frey (1845–1941) was born in Germany and came to the Amana Society in 1867. For many years, she was in charge of a communal kitchen in Main Amana. William Noé took this portrait of Frey in her church clothes in January 1939. When she died two years later, her obituary in the *Amana Society Bulletin* noted that she "possessed a remarkable memory and even at an advanced age she was able to regale her many friends who came to visit her, with stories of by-gone days."

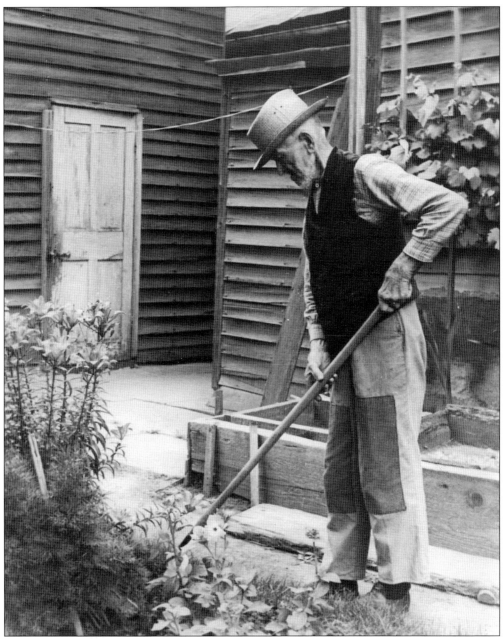

Heinrich Schmieder (1851–1945) of Main Amana was photographed at work in his garden by his neighbor William Noé. A native of Saxony, Schmieder came to the Amana Society at age 16 and worked as a harness maker. At the time of his death, he was the oldest member of the Amana Society.

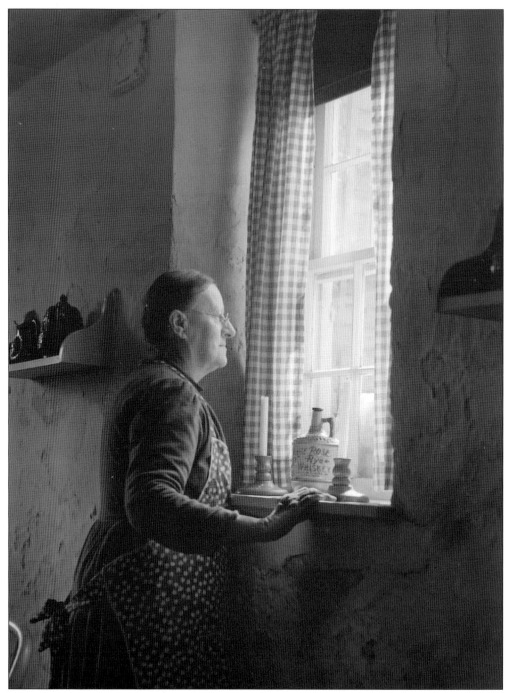

John Barry photographed Johanna Roemig (1866–1961) gazing out a window in the former communal kitchen she shared with her daughter's family. Roemig spent her entire life in Amana, except for a period late in life when she moved to Colorado to be cared for by a great-granddaughter.

Villages	Question #1		Question #2		No. sheets given out	No. sheets returned	spoiled	%
	Yes	No.	Yes	No.				
Amana	6	253	251	6	270	261	0	92.8%
Middle a.	65	122	50	117	204	199	0	24.5
High	10	52	33	10	63	63	0	52.4
West	6	54	81	5	88	87	0	9
South a.	6	103	106	2	110	110	1	96.4
Homestead	3	101	113	3	118	117	0	95.8
East a.	13	45	42	2	64	63	0	65.6
Total	109	730	676	145	917	900	1	73.7%
						75%		

Original sheet of tabulation of totals of question sheet. June 12 - 1931.

Peter Stuck served as the secretary of the Committee of Forty-Seven and on all but one of the subcommittees that facilitated planning for reorganization. As secretary, he tallied the response to the questionnaire sent to all members of the Amana Society in early June 1931 to gauge support for reorganization. Aware of its importance, Stuck preserved the original tally sheet among his personal papers. The totals recorded on this sheet demonstrated support for developing a plan of reorganization and thus marked the beginning of the reorganization. (Author's collection.)

19

Sind Sie damit einverstanden, daß der vorge=
schlagene Plan, die Amana Society zu reorganisie=
ren, welcher Ihnen kürzlich zur Durchsicht vorgelegt
wurde, angenommen und ausgeführt wird?

☐ Ja

☐ Nein

Pictured here is an original ballot printed for the February 1, 1932, election at which the members of the Amana Society approved the plan of reorganization by 96 percent. The ballot essentially asked residents if they supported the reorganization plan as it had been presented.

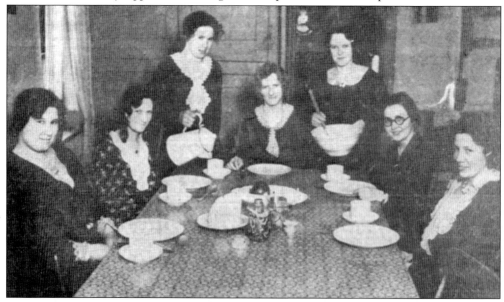

Several residents of the village of Homestead pose for a photographer from the *Des Moines Tribune*. On April 11, 1932, the image accompanied an article headlined "Colonists in Amana Light Last Fires in Their Community Kitchens." By 1932, few people actually ate in the communal kitchen dining rooms; most families took a basket of food home to eat privately. This image was captured in the dining room of the Beck kitchen house. This photograph was clearly posed: the diners are wearing their Sunday best, and not a morsel of food is to be seen! Pictured are, clockwise from bottom left, Henrietta Dittrich Hertel (1912–1994), Louise Kippenhan Selzer (1910–2005), Louise "Lizzie" Seifert Dittrich (1891–1984), Henrietta Roemig (1907–2003), Louise Schmeider Fels (1912–1969), Maria Eichacker Fels (1911–1999), and Louisa Berger Marz (1901–1986).

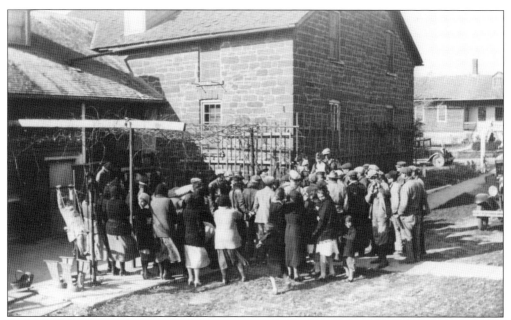

Rudolph Kellenberger photographed this auction at the Emil Miller kitchen house in West Amana during the late spring of 1932. As part of its reorganization, the Amana Society closed all 52 communal kitchens in its seven villages. Residents created kitchens in their own homes rather than obtain their food from the kitchens. In West Amana, auctions, attended by residents and outsiders alike, disposed of the contents of the village kitchens and butcher shop. Built in the 1850s of locally quarried sandstone, the Miller kitchen is still occupied by the Miller family.

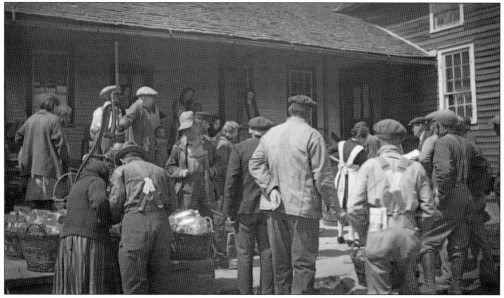

Kellenberger also documented the auction held at the kitchen house run by his future mother-in-law, Helen Mittelbach Schanz (1891–1976). Examining baskets at left are Otto (1912–1986) and Caroline Geiger (1901–1998) of West Amana. Most of the people visible in this and other auction photographs taken by Kellenberger were from the surrounding area and not members of the Amana Society.

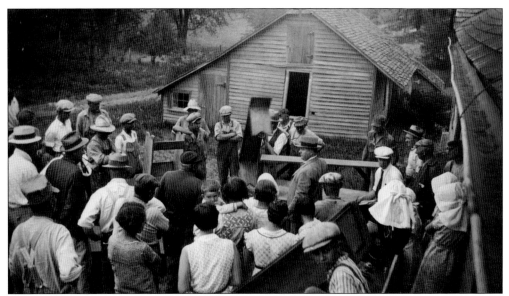

Rudolph Kellenberger climbed above the crowd for this photograph of the auction at the West Amana Meat Market. The meat market was remodeled into a residence. The frame shed in the background has long since been demolished.

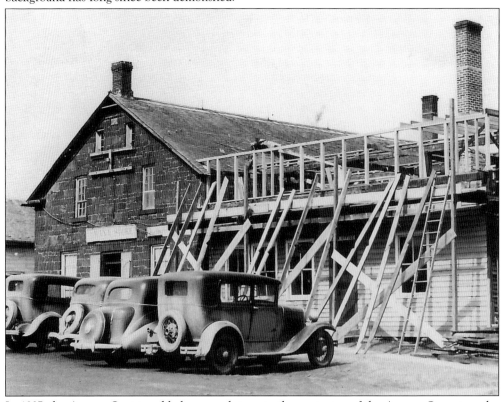

In 1937, the Amana Society added a second story to the east wing of the Amana Store in order to expand its corporate office. Known simply as the Main Office, it was in use until 1974, when corporate operations shifted to a new office building west of the village.

This photograph of the Amana Store and Amana Society Main Office was taken by John Barry in August 1937. The venerable stone portion of the structure, at left, continued to serve as a general store while a cadre of office personnel managed the affairs of the new Amana Society corporation in the wooden annex at right.

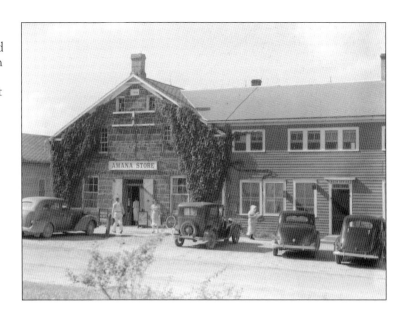

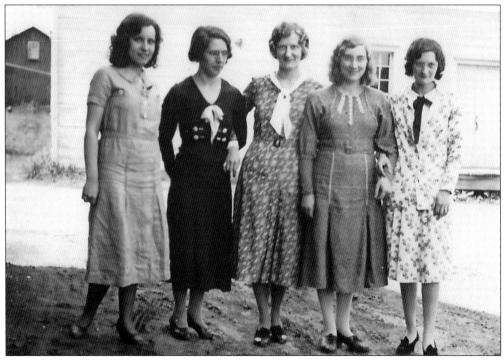

The women in this May 1933 group photograph by Rudolph Kellenberger were part of the first staff of the Amana Society Main Office. Women had a role in corporate management from the beginning. Pictured are, from left to right, Elizabeth Dickel Blechschmidt (1914–2013), Marie Blechschmidt (1899–1999), Henrietta Roemig (1907–2003), Irma Schanz Kellenberger (1914–2003), and Louise Kippenhan Selzer (1910–2005). One of them, Elizabeth Dickel Blechschmidt, worked in the Main Office for nearly 75 years.

The Very First Bulletin Out

Keep

AMANA SOCIETY

Corporation News Bulletin

Vol. 1 May 12th, 1932 No. 1

A bulletin, similar to this, will be issued from time to time to furnish information regarding our corporation, especially as to matters of business. Maybe a little personal item will slip in now and then to make the menu more tasty. Rhetoric and style, however, will receive secondary attention only, so the readers should take warning not to be too critical.

Monday, May 2nd, was a memorable day for the corporation. We all know that on that day the shift was made to work under a new system. The first few days were rather hard on all of us, the General Office was swamped with countless problems that needed immediate attention, and there were times when some of us felt like throwing up their hands and give up. But looking back now, the management here, including our able business manager, Mr. Barlow, wishes to congratulate everyone of our people on the fine spirit of co-operation shown by them during those trying first days. Each succeeding day was running a little more smoothly, the parts gradually worked in, although new problems continue to come up every hour of the day. We are not yet able to go at sixty per hour, but the efficiency has increased in an encouraging manner and we all feel confident, if the co-operation of the people continues, that we will be able to make the grade.

The force at the General Office deserves the highest praise for their unselfish devotion to duty. Fourteen hours a day was the general schedule during the past week with strenous, painstaking attention to seemingly endless columns of figures and salesslips and coupons by the bushel.

If Mr. Roemig has not lost any weight during the past two weeks we certainly miss our guess. We could not figure out yet, when he got his sleep, anyway he must have lost a lot. One thing, however, he did not loose as far as we were able to find out, and that was his temper. He was as even and unruffled at nine in the evening after a hard day as he was at 6:30 in the morning when he showed up ready for his daily round through the villages.

The managers of the various departments had their goodly share of the daily burdens and trials, and they certainly deserve a lot of praise and all the assistance our people may be able to give them.

All in all we are glad to say that we feel encouraged the way things are going and the progress we have made in getting the new system under way.

DECORATION DAY May 30th is to be observed this year as a full holiday. Holidays of course, means no wages, except where certain exceptions have to be made.

Those anxious to know about renting or buying shops, etc. should have patience just a little longer until a uniform policy has been decided on by the Board of Directors. Maybe we can tell you more about it by the time the next bulletin comes out. By that time we also hope to have our new charter, which will facsilitate matters considerably in dealing with matters of this kind.

Amana Society corporate secretary Peter Stuck published the first issue of the *Amana Society Corporation News Bulletin* on May 12, 1932, only 10 days after the initial reorganization. Stuck's intent was a newssheet to keep residents informed as the reorganization of the society progressed. He printed the first issues of the *Bulletin* on a mimeograph machine in the society offices; production moved to the Amana Print Shop that June. The *Amana Society Bulletin* evolved from a simple newssheet into a community newspaper that remains in publication today. Among his keepsakes, Stuck kept the very first copy of the *Bulletin*. (Author's collection.)

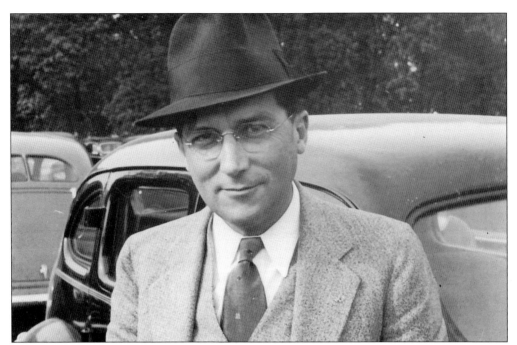

Peter Stuck (1890–1979), pictured here in May 1939, served as corporate secretary from 1932 to 1969. Stuck played a significant role in planning for reorganization and the creation of the new corporation. Stuck also started, and was the first editor of, the *Amana Society Bulletin*, played an active role in organizing Boy Scouts and other community organizations, and served on the school board and as a church elder and trustee. (Author's collection.)

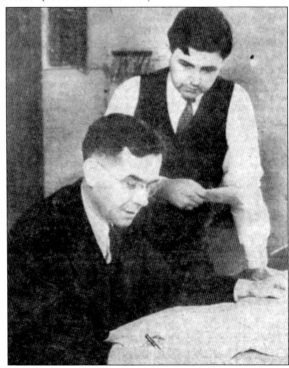

Sleepy Eye, Minnesota, native and Cedar Rapids businessman Arthur Barlow (1892–1983) was hired by the society leaders to serve as the business manager for the new corporation. Barlow served until 1944 and then returned as business manager at the time of the society's charter renewal, 1950–1952. Barlow was well respected, and his firm and measured guidance of the corporation was critical to its early survival. Here, Barlow (left) and William Noé (1898–1978), who served as the Amana Society treasurer for many years, pose for a photographer from the *Des Moines Tribune*.

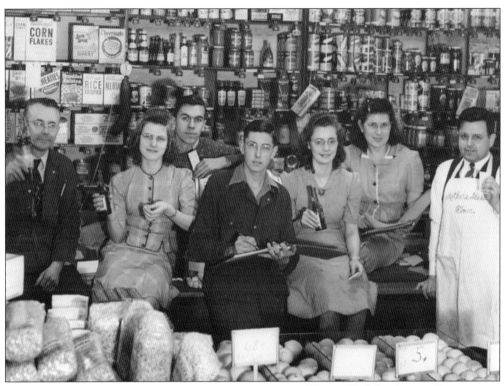

The staff of the Amana Store gathered for this lighthearted group photograph in the early 1940s. From left to right are Ferdinand Goerler (1900–1961), Drucilla Stumpff, Paul Zimmerman (1926–1999), Jackie Clemens, Marie Bretschneider Stumpff (1924–2008), Esther Schaefer Goerler (1905–2000), and William Noé (1898–1978).

In 1936, the Amana Society commissioned local artist John Eichacker (1910–1945) to design a logo. Eichacker represented the corporation with this scene of a woman wearing an apron and bonnet standing in front of an idealized Amana village. Commonly known as "the lady in the bonnet," this logo was used by the society through the 1990s. (Author's collection.)

Two

THE AMANA
CHURCH SOCIETY

During the communal era, the church was at the center of Amana community life. Church elders governed the society, appointed managers, and assigned jobs to workers. Society members attended nightly prayer meetings, daytime services on Wednesday and Saturday, and two services on Sunday. Marriages were subject to the approval of the elders, and members who disobeyed church authority could be kept from attending services or asked to sit in the children's row for a time. Church leaders prohibited worldly items such as radios, playing baseball, bobbing hair, or owning an automobile. By the 1920s, many restrictions had relaxed.

The reorganization of the Amana Society separated church and business matters. A separate Amana Church Society now governed church affairs. In the years following reorganization, the number of services was soon reduced to a single Sunday service in each village. In 1933, volunteers formed Sunday schools in each of the seven villages for the first time. After a time, the elders no longer required approval for marriages, and services such as the annual *Unterredung* (confessional service) disappeared.

For decades, the church remained the bastion of traditional Amana. In 1948, an Amana bride wore a white wedding dress for the first time. In 1961, the church started an English-language service for younger members who had trouble understanding German. Beginning in 1964, the village congregations began to merge with one another. In 1987, a woman was called to serve as an elder for the first time.

Presently, the Amana Church Society holds an early service with German hymns, prayers, and readings and a later service entirely in English, both in the Middle Amana Church building. Since the 1990s, most women no longer wear black caps, shawls, and aprons to services, and many men no longer wear suits. Some traditions, however, remain: men and women sit on separate sides of the sanctuary, services are conducted by lay elders, singing is a cappella, and a testimony from Christian Metz or other early leaders of the sect is read during worship. Members are still buried in order of death, their graves marked by simple concrete headstones.

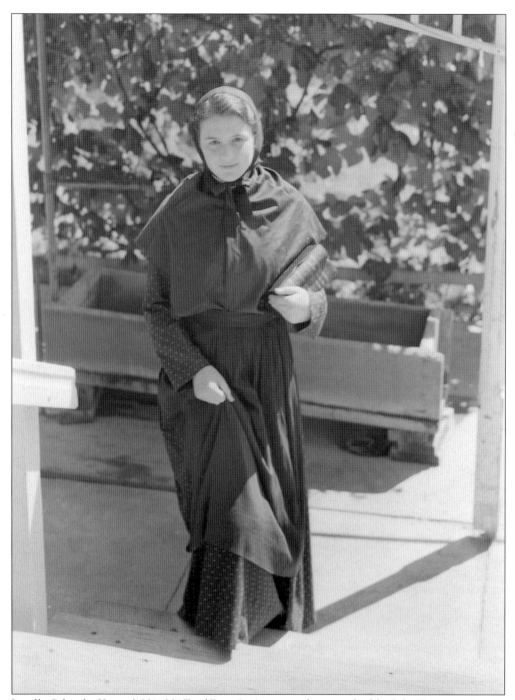

Lucille Schaefer Kraus (1921–2015) of East Amana was photographed by John Barry in August 1937 in the clothing that she wore to church. She is seen stepping onto the porch of the former kitchen house where she lived with her family. Schaefer is wearing a calico dress covered with the black cap, shoulder shawl, and apron worn by Amana women to church throughout the communal era and into the 1990s.

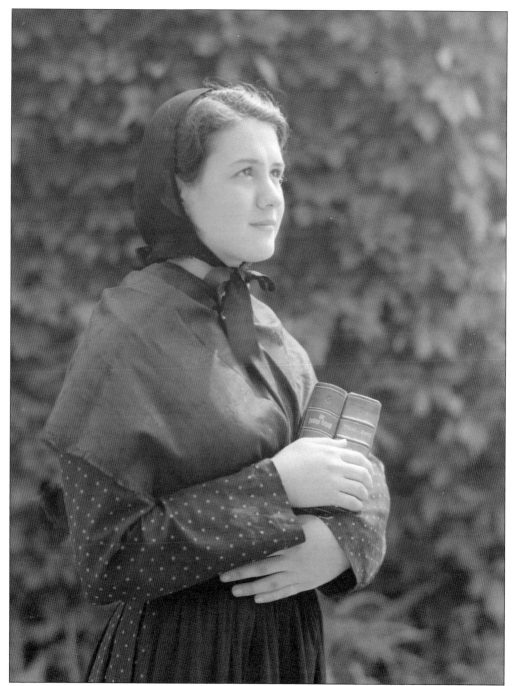

John Barry titled this photograph "Sunday in Amana." It shows Lucille Schaefer Kraus dressed to attend church services. The church clothing was a modification of the street dress worn by German women in the late 18th and early 19th centuries. Schaefer holds a copy of the *Psalter Spiel*, the hymnal compiled for the Inspirationists, and a German Bible.

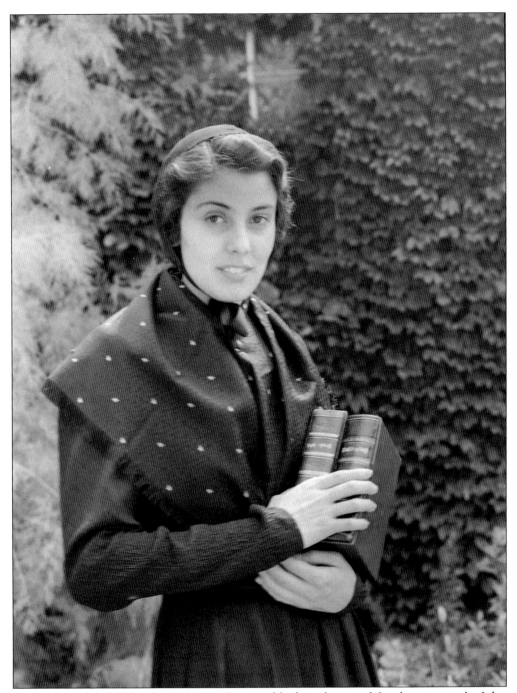

Cornelia Moershel Zuber (1920–) was 17 years old when she posed for this portrait by John Barry in August 1937. Then a high school student, Moershel went on to complete a bachelor's degree at Coe College, both accomplishments that would have been impossible for her under the communal system.

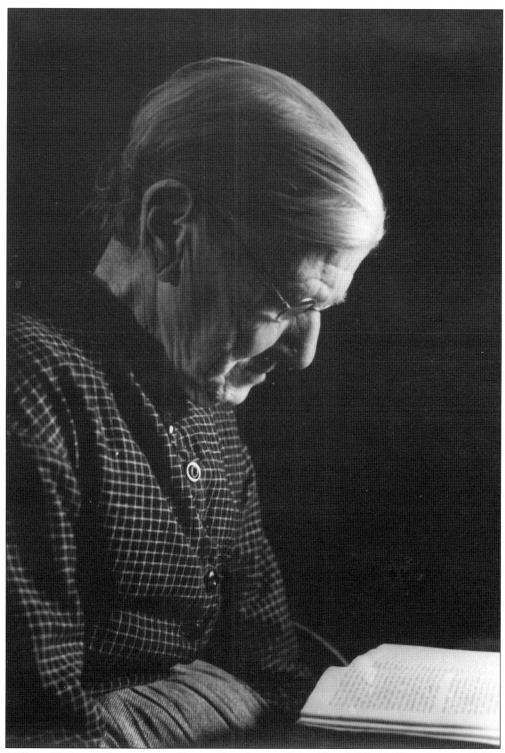

William Noé took this portrait of his mother, Lisette Hahn Noé (1875–1948) reading her Bible. Lisette Noé had been the manager of a kitchen house during the communal era.

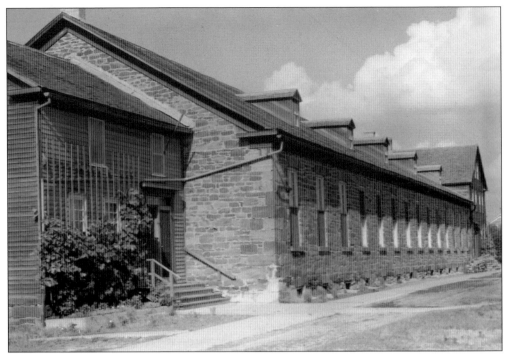

The main meetinghouse, or church, in the village of Amana was built in 1864. John Barry photographed this building from two angles during August 1937. This view is looking east. The 90-foot-long sandstone section of the building contains the meeting room used for Sunday worship. The frame portion of the building at left housed apartments for community members. This building continues to be used by the Amana Church Society today.

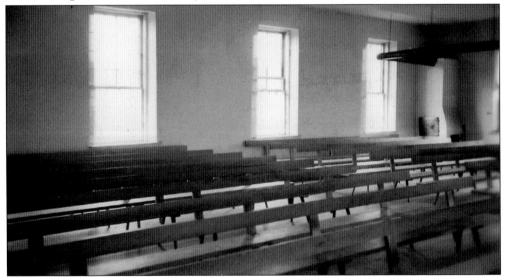

Paul Kellenberger (1909–2003) photographed the interior of the West Amana church in 1937. Members sat on the plain scrubbed wooden benches, men on one side and women on the other, separated by a central aisle. Services continued to be held here until 1972, when the West Amana congregation merged with South Amana. Currently, the building houses the art studio of Michelle Maring Miller.

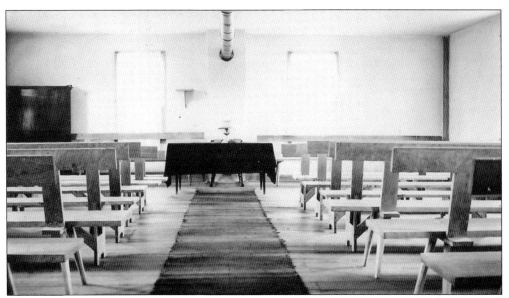

During the communal era, Amana residents attended prayer services each evening, as well as services during the day on Wednesday, Saturday, and twice on Sunday. For the evening services, members typically gathered in smaller meeting rooms, such as this one in West Amana, attached to a residence. By the time this space was photographed by Paul Kellenberger around 1937, the community was reducing the number of services each week, until, by the 1940s, most Amana villages typically met once a week, on Sunday, for worship. Residents typically remodeled the smaller meeting rooms, like this one, into additional living space. The table at center was where the elder in charge of leading the worship service on a particular evening sat.

John W. Barry captured this scene of men leaving a church service at the large meetinghouse in the village of Amana. William Noé (1898–1978), the young man at far right, was a gifted amateur photographer whose work is among that featured in this book. The stone building behind the men was built in 1856 as the first church in Amana. In 1864, a larger church was built, and this structure, known as the Lauer Saal for its longtime caretaker, Henry Lauer (1859–1938), was used for evening worship services.

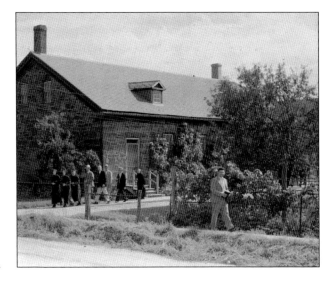

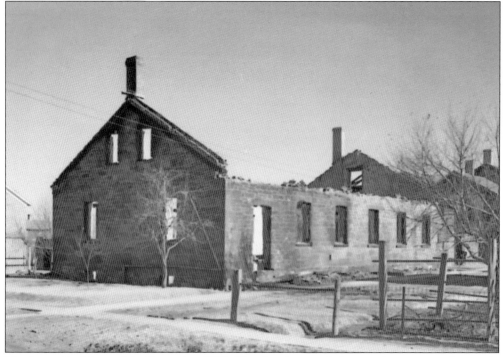

The Lauer Saal burned in November 1938. The fire destroyed the meeting room and severely damaged the attached living quarters. Henry Lauer, the elderly man who lived in the building, died from smoke inhalation. Church leaders decided to demolish the ruins and offer the stone to Amana residents for residential building purposes.

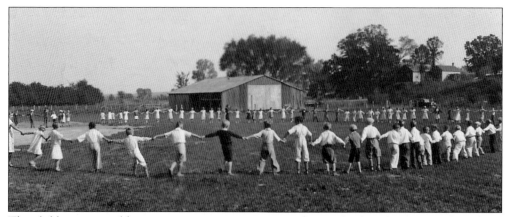

The children pictured here are participating in a game during the first Amana Sunday school picnic, held on September 9, 1934. During the communal era, the village schools had instructed children in religion during a special Saturday session. With the end of communal living, church volunteers started Sunday schools in each village. The picnic was attended by over 500 people and held at the baseball field below the village of Middle Amana. (Author's collection.)

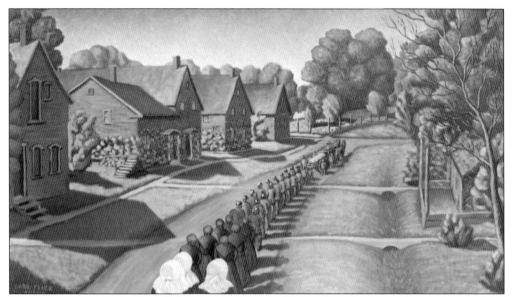

West Amana painter Carl Flick (1904–1976) set a goal to produce paintings that depicted scenes of communal Amana life, which he felt would be forgotten. Flick's 1935 painting *Amana Funeral*, seen here, was widely exhibited and is his best known work. The mourners are seen following the horse-drawn wagon bearing the body to the cemetery in a double row. This practice continued until the last horse-drawn funeral in 1951. Flick's painting is now in the collection of the Amana Heritage Society.

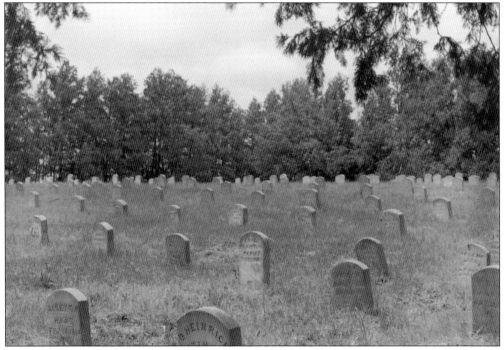

For this view, John Barry set up his camera in the extreme northeast corner of the Amana Cemetery. Then, as today, members are buried in chronological order of death, with their graves marked with a headstone typically bearing their name, date of death, and age.

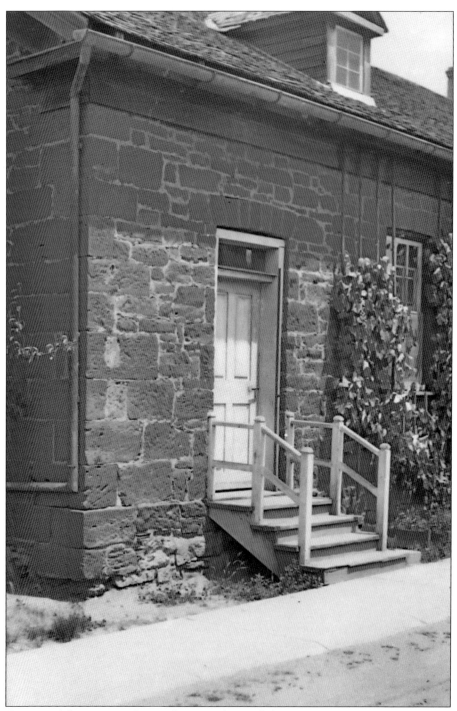

The doorway of the Lauer Saal was a favorite subject of photographers visiting the Amanas. The sandstone used in this building was quarried from a hillside only a few hundred yards from the building site. The trellis on the walls supports climbing grapevines. These trellises were found on almost every building during the communal era and were meant to help keep the interiors cool in the summer as well as to contribute to the village fruit and wine crop.

Three

THE AMANA
SOCIETY FARMS

When the Amana Society reorganized from communal living in 1932, its 26,000 acres of farm land became the property of the new Amana Society corporation. Although horses remained the primary power source on the farm in 1932, the seven Amana farm departments had already begun to transition to tractors as early as 1915. The 1930s, and particularly the war years of the early 1940s, found this transition toward more mechanized agriculture accelerating. By 1945, few horses remained in the village barns, soybeans and hybrid corn had replaced small-grain crops and communal-era produce such as potatoes and onions, and the huge kitchen house gardens were only a memory.

During the 1930s, each Amana village was in the center of its own farm department, with an overall farm manager, and each farm consisted of approximately 2,000 acres of land. The farms represented the largest asset of the new corporation and also were the largest employers within the villages (in 1935 the farms employed 283 people full time). Each farm maintained dairy herds as well as beef cattle. Some of the farms, most notably the East, West, and South Amana departments, continued to raise sheep.

After the reorganization, some of the farm departments hired women to maintain a corporation garden to produce vegetables for sale. These gardens were abandoned by the 1940s. In the villages of Homestead and High Amana, women were hired to detassel the large plots of hybrid seed corn that those departments raised for the Hi-Bred (later known as Pioneer) Seed Corn Company of Des Moines.

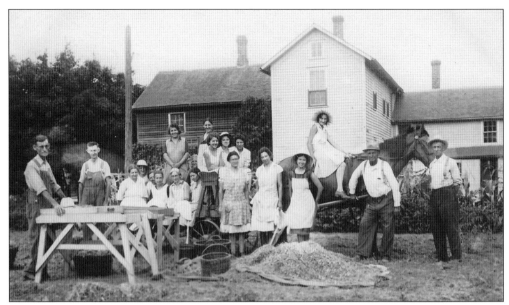

This photograph, taken only months after the end of communal living, demonstrates how some tasks, such as harvesting the huge village onion field, remained communal even after the reorganization. Beginning in the 19th century and continuing into the 1930s, the society marketed onions and onion seed throughout the Midwest. The woman seated on the horse is Louise Kippenhan Selzer (1910–2004). Holding the horse's bridle is Samuel Schaup (1860–1937), who served as the railroad station agent at the Homestead Depot during the communal era. (Author's collection.)

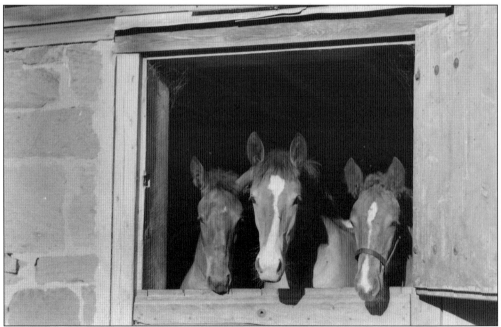

In 1937, when John Barry photographed this trio of horses, tractors were fast becoming the main means of motive power on the Amana farms. The society purchased its first tractor in 1915, and by the end of World War II, very few horses remained on the farms. These three animals are peering through a window, probably in the large Main Amana horse barn.

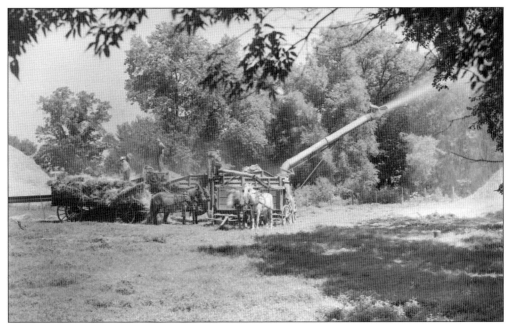

This threshing scene was photographed by John Barry in 1937, probably near the village of Amana. The *Amana Society Bulletin* of August 19, 1937, reported that threshing at Amana "was finished on Saturday and the threshers went on a picnic on Monday to celebrate the occasion."

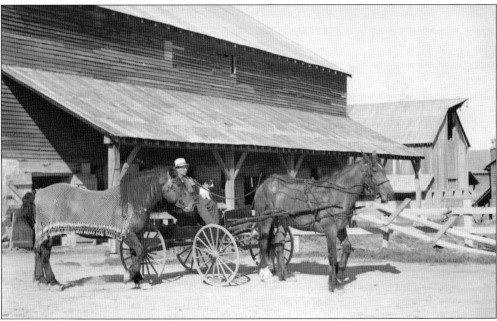

The Middle Amana horse barn forms the background of this August 1937 photograph taken by John W. Barry. Built in 1880, the barn is still standing and in use by the Amana Society. The man in the buggy is one of the society's hired farm workers, Jacob Jaeger (1863–1942), who lived in Upper South Amana and cared for the society's lone breeding stallion. When needed, Jaeger delivered the stallion to a particular village for breeding purposes, driving his buggy and leading the stallion with a rope, as pictured here.

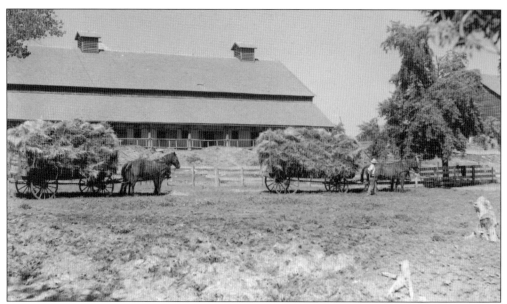

These wagons loaded with straw were photographed by John Barry in August 1937. The massive barn behind them is the Amana Dairy Barn, the largest barn in all of the Amana villages. Originally built in 1856–1857, the barn burned to the ground twice: in 1884, and again on August 17, 1900, and was quickly rebuilt each time. In 1999, the Amana Society converted the unused structure into a *Festhalle*. It serves as the main venue for the annual Amana Oktoberfest, dozens of wedding receptions, and other events.

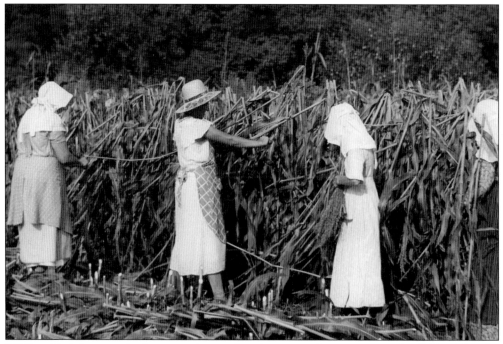

William Noé photographed community members harvesting broom corn in the 1930s. After the harvest, the seed heads at the top of each plant were run through a machine to remove the seeds; the resulting broom straw was dried and stored until needed by the village broom maker.

40

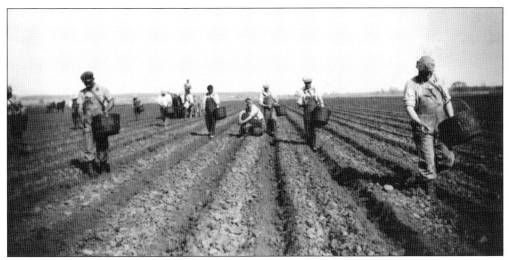

For some years after the reorganization, the village farm departments continued to plant large fields of potatoes for local use. Here, a crew plants a field near West Amana, as photographed by Rudolph Kellenberger. In 1935, the seven farm departments planted 196 acres in potatoes, together yielding a total of 7,150 bushels.

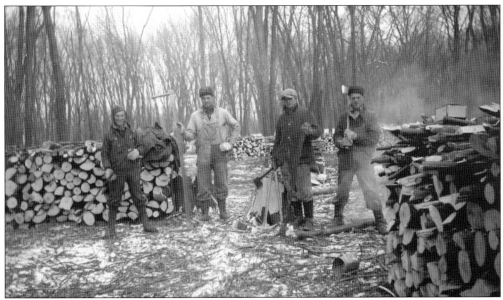

A regular duty of Amana farm workers was cutting wood for winter use in the over 7,000 acres of timberland surrounding the Amana villages. The crews hauled logs into the villages by sled or wagon. The crew seen here was photographed by Rudolph Kellenberger near West Amana during the winter of 1933. In the 1930s, the society supplied two cords of soft wood to each elderly or infirm person who was living off their stock shares.

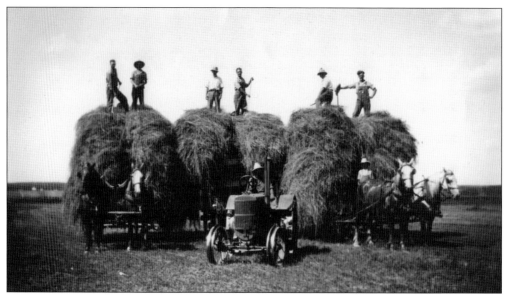

In 1934, Rudolph Kellenberger photographed the West Amana farm crew using both horses and tractors to pull loaded hay wagons back to the village barns. Kellenberger's brother Paul (1909–2003), who was also the West Amana schoolteacher, stands at right on top of the wagon at center.

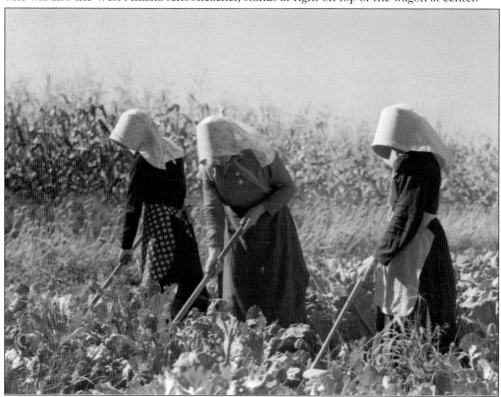

This photograph by John Barry shows three women in sunbonnets working in a garden patch, probably at Homestead. For a few years following the reorganization, the society hired women to plant and maintain commercial gardens to raise saleable produce.

This is one of several atmospheric Amana farm scenes taken by William Noé and shows a farm worker pitching a bundle of straw. Noé experimented constantly with his photographic technique and worked hard to raise his work to a professional level.

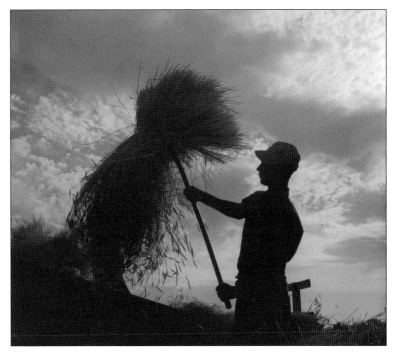

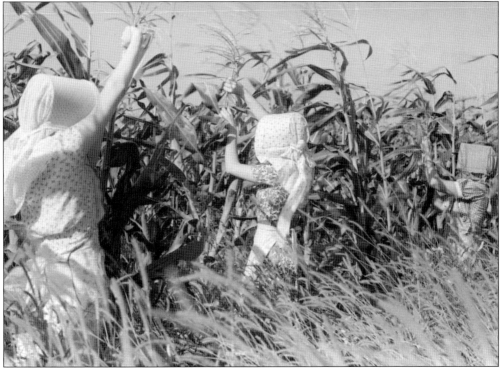

In July 1937, John Barry recorded a series of photographs of Amana women, probably in the village of Homestead, detasseling hybrid corn. Beginning in 1928, Homestead farm manager Louis Selzer (1889–1960) contracted with the Hi-Bred Corn Company (known as Pioneer Hi-Bred after 1935) to raise seed corn in designated plots. Women did the corn detasseling, usually in July.

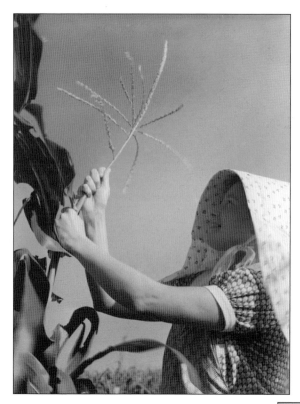

Alma Goerler Ehrle (1904–1984) was a member of the Homestead detasseling crew. Members of the crew were often drenched by the dew that clung to the cornstalks, burned by the Iowa sun, and fatigued by the physical strain of detasseling, yet they were grateful for the extra income the work provided for their families.

The Homestead detasseling crew ranged from grandmothers to junior high students. In the early 1940s, the crew poses with farm manager Louis Selzer's truck, used to haul them to and from the hybrid corn fields. After weeks of hard work detasseling corn, the women enjoyed a well earned annual picnic and outing by the village ice pond. (Author's collection.)

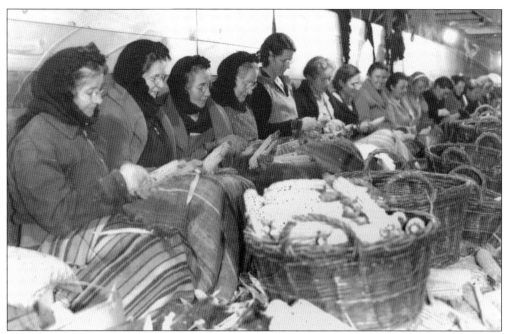

On a chilly October day in 1937, William Noé photographed the crew of mainly women who husked and sorted hybrid seed corn in a Homestead corn crib prior to it being bagged and trucked to the Hi-Bred Corn Company facility at Durant, Iowa. The three women on the left are, from left to right, Lizzie Dittrich (1891–1984), Caroline Selzer (1889–1974), and Henrietta Selzer (1892–1968). Note the Amana willow baskets and the old rag carpets pulled over legs in order to combat the chill of an Iowa autumn.

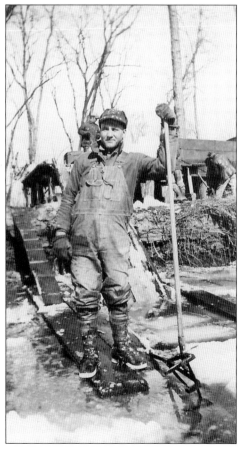

Another regular duty of Amana farm workers that continued in the years immediately following the communal era was harvesting ice. Stored in icehouses between layers of sawdust, the huge blocks would be delivered to kitchen houses, and later homes, to cool iceboxes used for food storage. Rudolph Kellenberger photographed his neighbor George Miller (1912–1997) standing by the ramp where workers pulled the ice out of the Iowa River and loaded it onto sleds. In 1935, the West and South Amana farm departments jointly harvested 213 wagon loads of ice from the river. When they reached West Amana, a second team was hitched to each wagon in order to pull it up the steep hill.

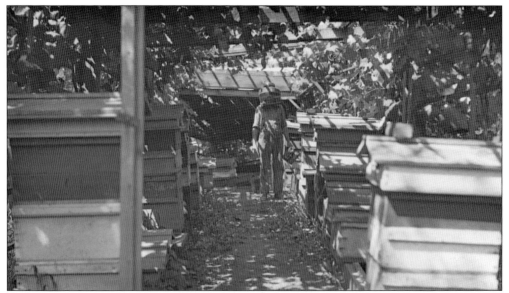

During the communal era, each village had its own apiary and beekeeper. In 1932, the society offered all of the apiaries and their equipment to the highest bidder. Rudolph Schaefer (1895–1957), posing here with his hives for William Noé, paid $70 for the East Amana bee equipment.

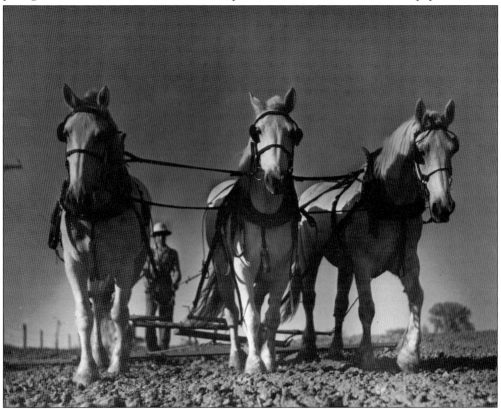

This photograph of draft horses harrowing a field was taken by John Barry in 1937. This is the only photograph from Barry's Amana series for which the original negative no longer survives.

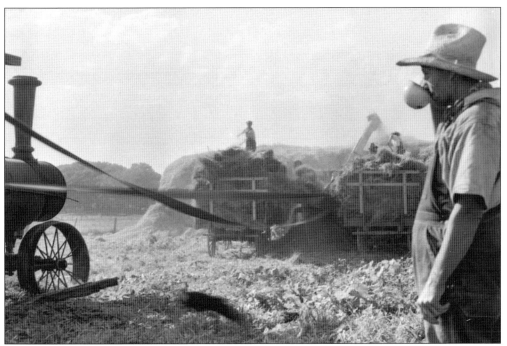

John Barry photographed this threshing scene in August 1937. The worker at right is drinking a dipper-full of cool water. The huge steam engine powering the threshing equipment is at left, connected to the machinery by the leather belt at center.

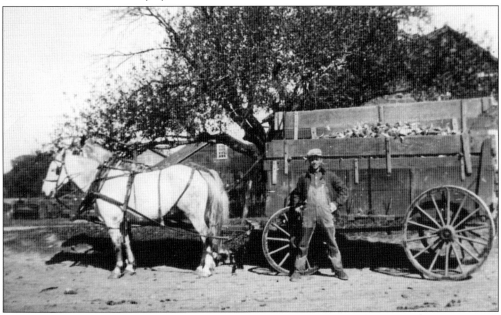

Rudolph Kellenberger photographed his brother Conrad (1912–1987) with a wagon full of hand-harvested field corn. The worker harvesting the corn walked beside a horse-drawn wagon like this pulling ears from the stalk in a swift, rhythmic motion and throwing them against the high wall on the opposite side of the wagon so that they would bounce into the wagon bed. The gable of the West Amana blacksmith shop is visible just left of the wagon.

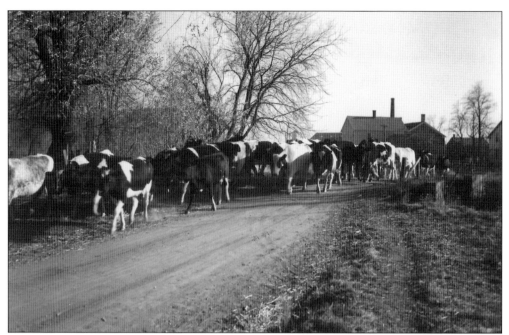

This herd of dairy cattle was photographed by William Noé in the 1930s as they were being driven down the main street of Amana. Each village farm department maintained a dairy herd into the 1960s. In 1935, around the time of this photograph, the seven farm departments together had 394 milk cows.

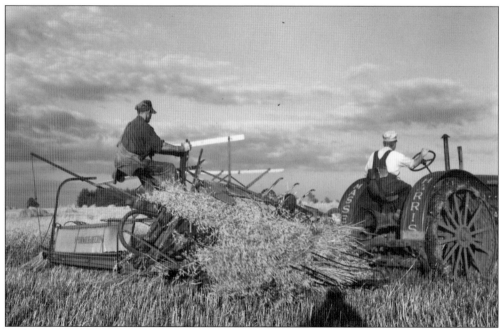

In this scene, a farm worker drives a Massey Harris tractor pulling his coworker, who is operating the binder, creating bundles of oats that were later stacked in shocks to dry before being threshed. Massey Harris was a forerunner of Massey Ferguson, a name adopted following a merger in the 1950s.

William Noé took this striking photograph of August Rothenbüchner (1898–1972) of the Middle Amana farm crew, pausing for a cigarette while seated atop the dump rake that he operated during hay making.

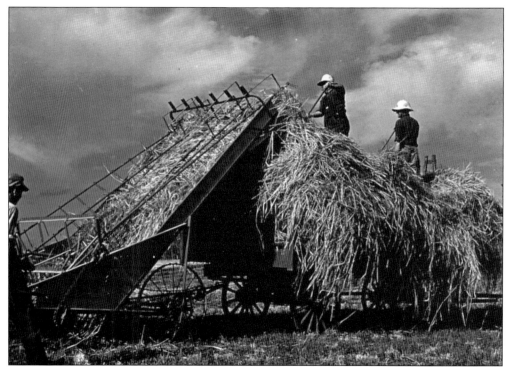

William Noé photographed a crew at work with a hay loader, stacking hay on a wagon to be taken into the village for storage. The process of producing hay required several steps: first, a mowing machine cut the hay, which was left to dry in the field. It was then collected into windrows by a horse-drawn hay rake and finally lifted from the ground to a wagon by a hay loader. In 1935, the seven farm departments devoted 2,012 acres to hay fields, from which they harvested an estimated 3,312 tons.

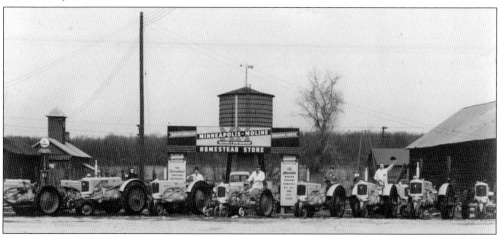

William Ehrle Jr. (1902–1969), the manager of the Homestead Store, developed a large implement dealership. The dealership specialized in Minneapolis Moline tractors, and the harvest gold and red machines became common on the Amana farms. Here, some of the implement department staff poses with their stock around 1940. The unique pump house, which was built in 1894 to house the pump needed to draw water from the village's deep well, is at left. The town water tower is at center.

Four

CRAFTS AND TRADES

During the communal era, many different trades were to be found in the Amana villages. Many of these trades, such as wagon makers, wheel wrights, blacksmiths, carpenters, coopers, butchers, tailors, bakers, tinsmiths, cobblers, and printers, might be found in virtually every small Iowa town of the late 19th century. Others, such as soap makers, basket weavers, carpet weavers, watch and clock makers, and broom makers, were less typical for the time and place. Amana trades were also distinguished by the old-world techniques that were passed down from one generation of workers to the next.

With the reorganization in 1932, the Amana Society leadership reviewed all of the small craft and trade shops and decided which businesses to maintain under corporate ownership, which to combine, and which to close and offer the buildings and equipment for sale. Some businesses, including the watch maker, tinsmiths, and cooper shops, closed in 1932. The society offered the equipment and buildings for sale. Many craftsmen purchased their equipment and continued to work at their particular trade, usually as a sideline for many years. Some trades, such as coopering, completely disappeared after 1932. Others, such as the village bakeries and meat markets, continued under the Amana Society but very quickly consolidated operations in centralized locations. Some trades, such as tin smithing, disappeared with the end of communal living only to be resurrected decades later through the Amana Arts Guild's efforts to revive traditional folk arts and crafts beginning in 1978.

Today, the Amana villages are home to practicing potters, blacksmiths, basket weavers, carpet weavers, furniture makers, wine makers, and bakers, demonstrating a renewed appreciation of traditional handwork, which had disappeared during the nation's rush to modern machine-made goods in the early 20th century.

In the 1930s, many of the traditional craftsmen of communal Amana provided ready subjects for photographers intent on capturing trades that were already anachronistic at the time.

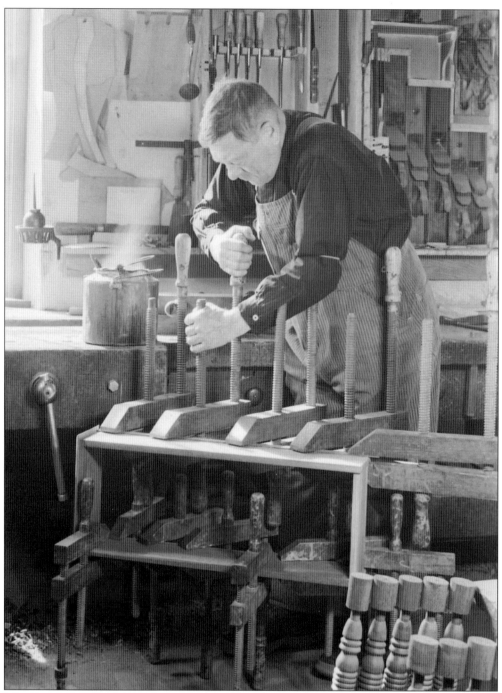

John Barry photographed Amana Cabinet Shop manager August Franke (1874–1953) applying clamps to a piece of furniture in August 1937. On the wall above Franke's workbench are templates used to cut out the various parts of different pieces of furniture as well as some of the wood planes used in the shop. The steaming pot on the bench holds hot glue, which Franke has applied to this furniture piece with a brush.

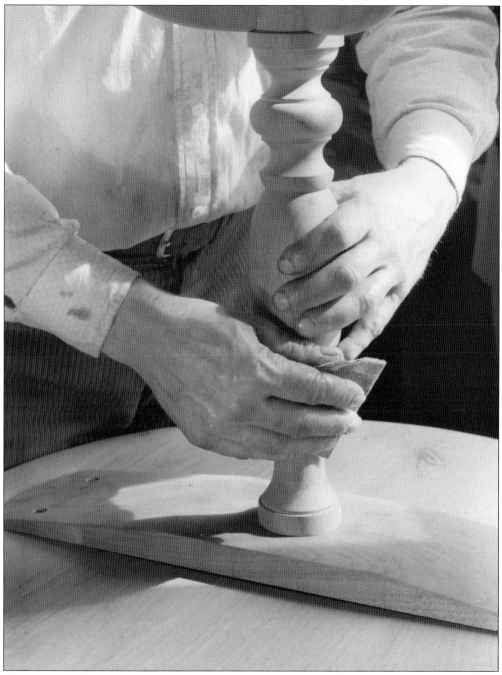

This photograph of an Amana craftsman's hands sanding a table leg was taken by John Barry in August 1937. The man posing for Barry was probably August Franke. This was one of several Barry images used in advertising publications by the Amana Society.

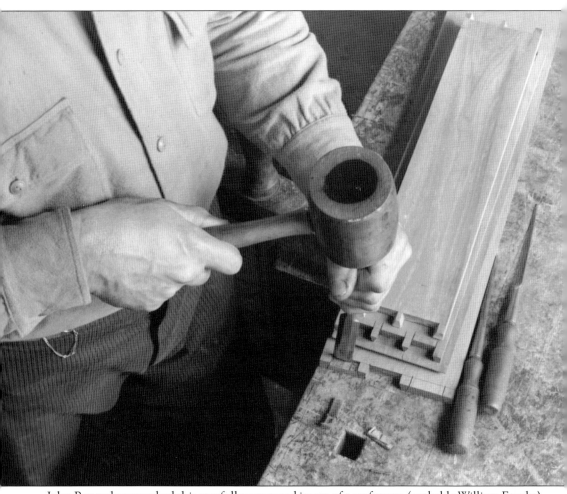

John Barry photographed this carefully composed image of a craftsman (probably William Franke) cutting dovetails by hand in August 1937. In 1934, the seven Amana cabinet shops were combined into a single furniture facility, housed in the former Amana Calico Mill in Main Amana.

John Barry captured several views of the Amana Meat Market, including this view of the iconic 1858 smoke tower, during his visits to Amana in 1937. Built of sandstone, the tower was used to smoke sausages and hams in season. Still a local icon, modern health regulations no longer permit its use.

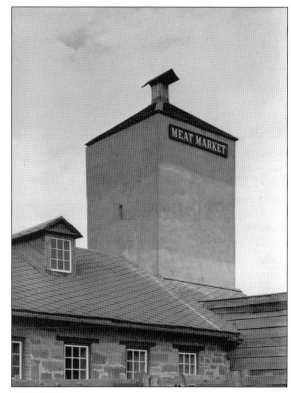

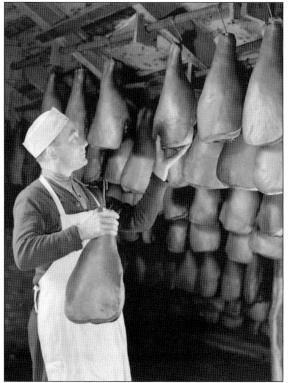

Barry was fascinated by the hams aging in the garret of the Amana Meat Market, as he took several photographs of them. Manager Walter Schuerer (1897–1948), seen here, had been in charge of the East Amana Meat Market prior to 1932.

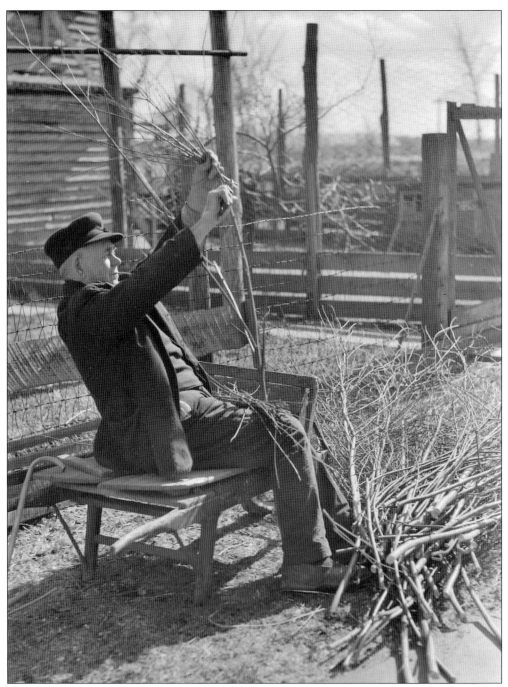

The man sorting willows for weaving into baskets in this photograph is identified as Ludwig Dietrich (1851–1937). Since Dietrich died on May 25, 1937, this photograph suggests that John Barry actually took some of his Amana views earlier than August 1937.

In this photograph, several hearty loaves of thick-crusted bread are arranged inside the brick oven. Each Amana village had a bakery, and each bakery contained a brick oven of similar design, typically 10 feet square and approximately 15 inches high. Each morning, the baker filled the oven with thinly split wood. After the wood burned to coals, the baker swept them into an ash bin, swabbed the oven with a damp mop, and placed loaves inside to bake. The dough for each loaf had been allowed to raise inside a rye straw basket, like those positioned on either side of the oven in this view.

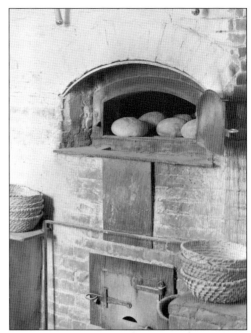

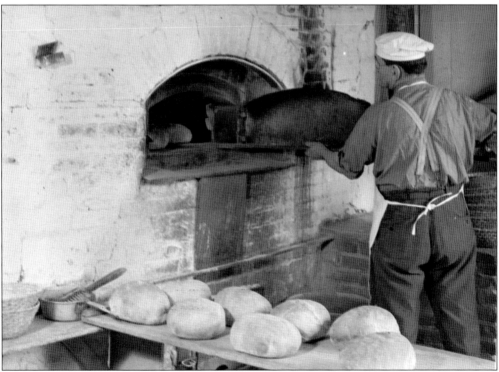

George Schmieder (1880–1960) baked bread for the Main Amana communal kitchens in a 100-foot-square stone and brick oven in his family home. In 1942, a few years after John Barry photographed Schmieder at work, the Amana Society consolidated all baking at a single commercial bakery in Upper South Amana. The Schmieder family lost little time in removing this oven and converting the large space into a modern family kitchen.

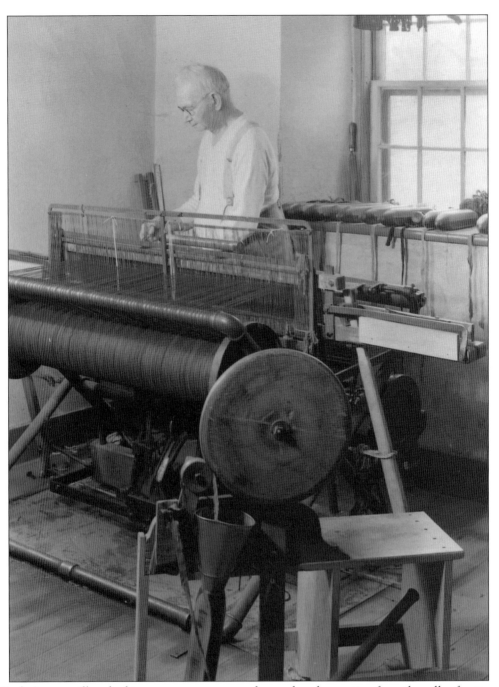

Each Amana village had its own carpet weaver who produced carpeting from the rolls of cotton and woolen strips prepared by residents. High Amana weaver Emil Schaufuss (1854–1946), photographed here by John Barry, used a semiautomatic loom. A mechanism shot a metal shuttle through the warp when the operator pulled the loom frame to tamp the previous row of material into place. Residents would whip stitch the completed strips together and then stretch and tack them to their floors. Typically, carpets were woven from cotton rags that had been dyed blue or brown at the woolen mill, with other colors, such as black or green, used as accents.

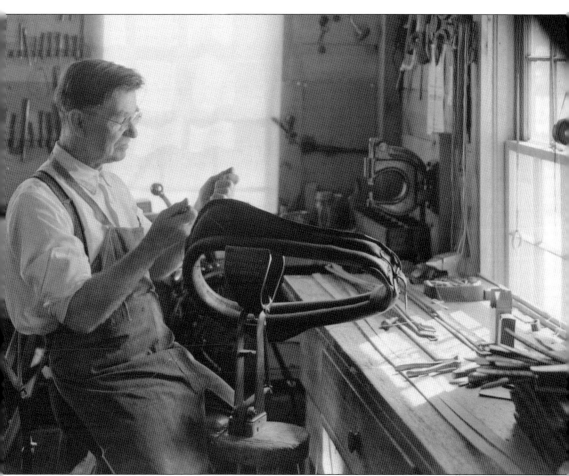

Homestead harness maker Fred Marz Sr. (1868–1945) was born in Germany and came to the Amana Society with his parents in 1873. A harness maker for over 50 years, Marz also repaired shoes and continued to work until shortly before his death, when he was the last active harness maker in the Amanas. Marz was also a church elder, among many other roles that he performed in the life of his village.

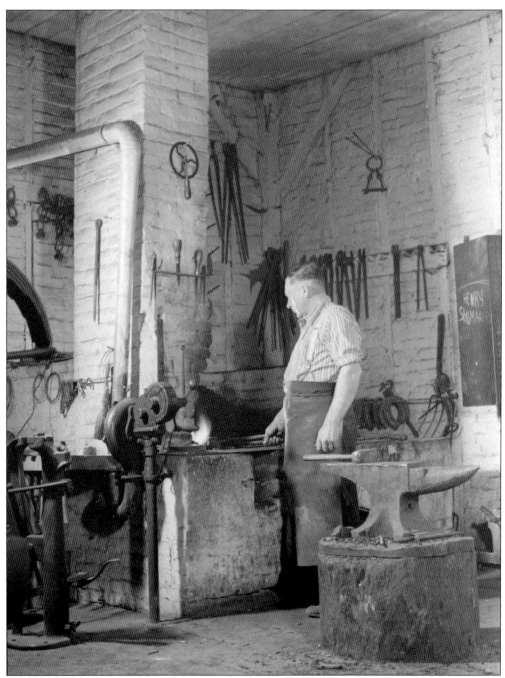

The services of blacksmith Henry Schuhmacher (1895–1958) were still much in demand in 1937, when this photograph was taken by John Barry. At that time, the Amana farms still relied heavily on horse power, and Schuhmacher was kept busy shoeing horses and repairing farm equipment. The Main Amana blacksmith shop where Schuhmacher worked continued in operation until the death of his successor, Carl Ackermann, in 1961. The shop stood in front of the Amana Meat Market, which was later relocated for use as a farm building and demolished.

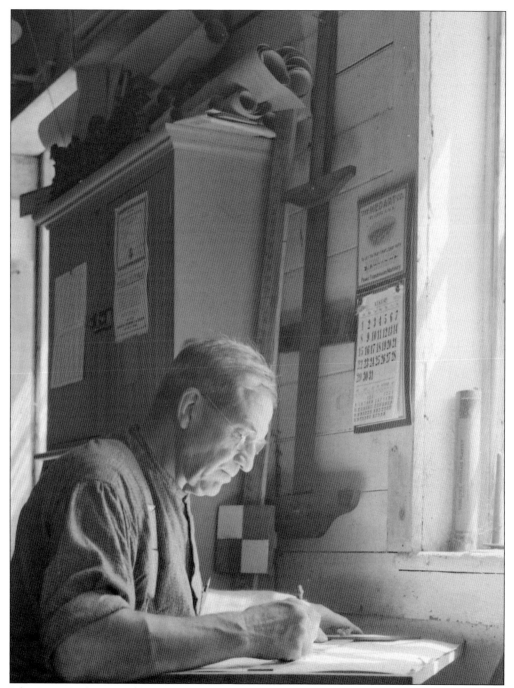

John Haas Sr. (1877–1952) was photographed by John Barry in August 1937 drawing a blueprint. Haas was the longtime manager of the millwright shop at the Amana Woolen Mill. Known for his technical skill, Haas played an important role in planning the reconstruction of the Mill following the 1923 fire that destroyed 10 buildings in the mill complex. Haas also served as a church elder from 1917 until his death.

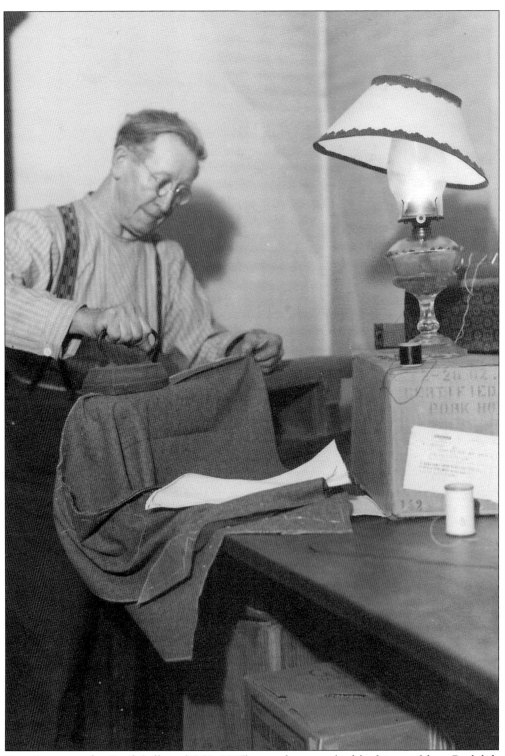

East Amana tailor Emil Solbrig (1868–1945) was photographed by his neighbor, Rudolph Blechschmidt, in the 1930s.

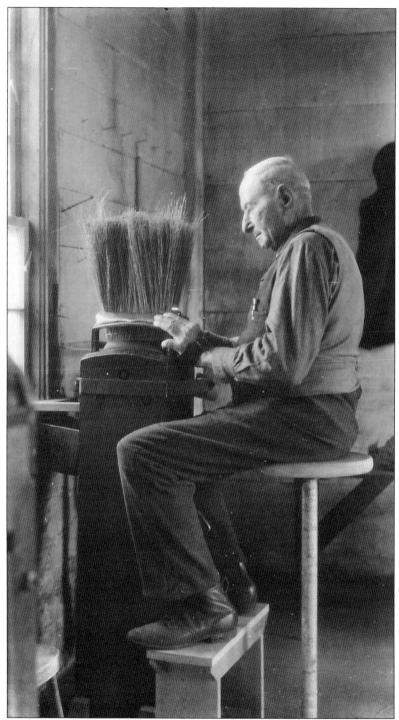

Jakob Murbach (1855–1940) made brooms for the village of Amana. Each Amana village had its own broom maker during the communal era, and these were typically older men unable to work at more strenuous activities. This photograph of Murbach, although attributed elsewhere to William Noé, was actually taken by Peter Stuck, who carefully dated the image in his album.

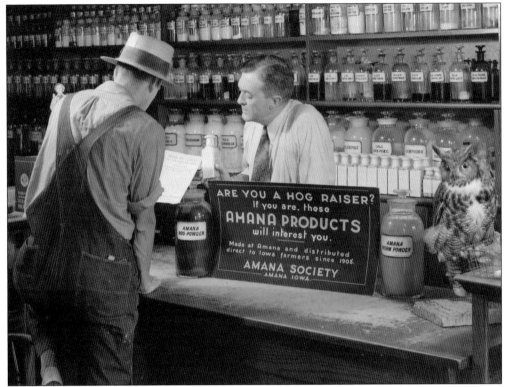

F. William Miller (1876–1952) was the great grandson of Amana Society founder Christian Metz. As a young man, Miller briefly left the society, returned, and was chosen by the elders to receive training as a pharmacist. In addition to medicines, Miller also manufactured and sold treatments guaranteed to cure digestive issues with hogs. When John Barry and Paul Engle visited the pharmacy, Miller took advantage of the situation to have Barry take a series of promotional photographs for his products. Here, Paul Engle poses as an interested farmer. The stuffed owl at far right was one of several curiosities that decorated Miller's pharmacy.

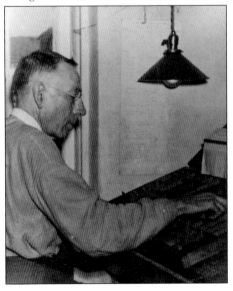

Gottlieb Herr (1878–1963) began helping in the Amana Society Print Shop at Middle Amana at the age of nine and spent most of his working life there. Herr also served as a teacher during the communal era. At his composing table in the print shop, he handset the type for countless religious books, advertising sheets, and the weekly *Amana Society Bulletin*. All type at the print shop was hand-set until 1953, when the society purchased a linotype machine.

Five

INDUSTRIAL AMANA

Despite its quiet rural location, Amana has always had industrial manufacturing. The production of quality woolen goods, including flannel, blankets, and knitting yarn, provided important income for the society. The woolen mills at Amana and at Middle Amana together employed over 100 workers and supplied customers nationwide. The Amana Calico Mill, in operation until 1918, produced thousands of yards of printed fabric each year.

By 1932, Amana's industrial production centered on the woolen mills. To improve manufacturing efficiency, the society consolidated the two mills at Amana by 1939. Military contracts for flannel for uniforms and blankets, however, sent production soaring and necessitated rapid expansion of the mill. The factory operated as a full-process woolen mill until 1985 and today continues to produce a line of blankets and other textiles for national sale.

High Amana native George C. Foerstner (1908–2000) started selling electrical appliances in 1934 and soon began manufacturing commercial coolers. Foerstner's operation, the Electrical Equipment Company, grew quickly. The Amana Society bought the company in December 1936, retaining Foerstner as general manager. The new Amana Society Electrical Department continued to grow, using the former Amana cabinet shop for office space and the former Middle Amana Woolen Mill for production. Employees produced coolers for installation in taverns, groceries, and restaurants across the Midwest. World War II military contracts led to dramatic and rapid expansion. Fires in 1941 and 1943 destroyed the original manufacturing facilities but barely slowed production, as employees worked in other buildings around the villages. In 1950, the Amana Society sold the electrical division to Foerstner and other investors. Under Foerstner's continued leadership, the company, then known as Amana Refrigeration, became the sixth-largest appliance manufacturer in the country. Innovations such as the first upright freezer and the first home microwave oven—the Radarange—helped the company remain a leader in the industry and made the name "Amana" a household word.

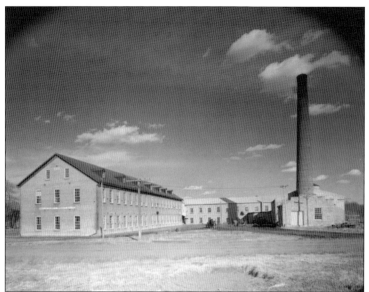

This 1937 photograph by John Barry shows several of the buildings at the Amana Woolen Mill complex. At left is the long weaving building, constructed in two stages in 1891 and 1908. At center is the 1859 spinning and carding building. At far right is the iconic smokestack, connected to the mill's steam engine, housed in a brick building visible behind the cement block structure at right.

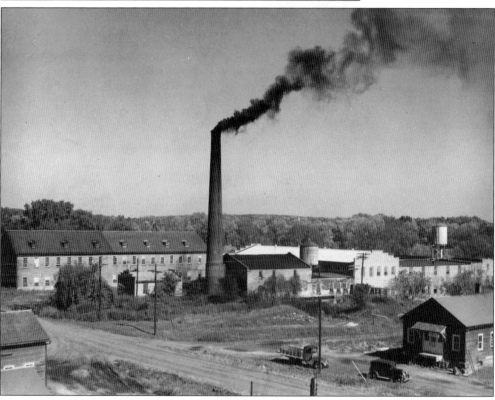

This view of the Amana Mill Complex was taken from south of the factory. Visible are the weaving building at far left, the smokestack and powerhouse at center, the spinning and carding building at center right behind the water tank, and at far right, the dye house and wool storage buildings. In the late 1860s, the society dug a seven-mile millrace to channel water from the Iowa River to the mills at Amana and Middle Amana. When water flow was insufficient, the huge steam engine was called into action to power the mill machinery.

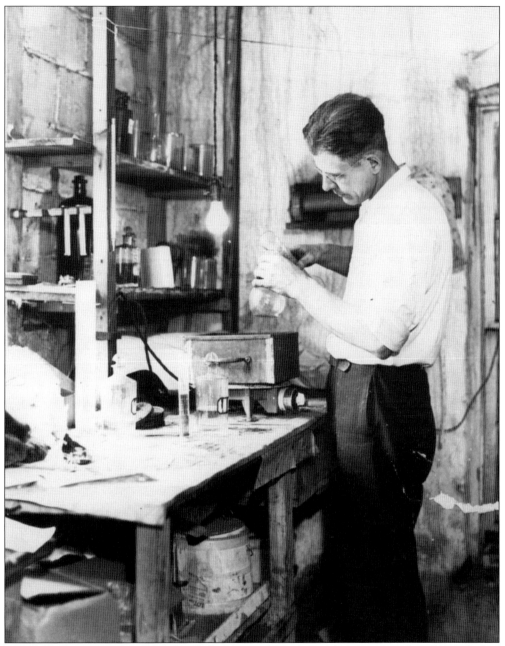

Originally from Homestead, Carl Kolb (1900–1986) later moved to Amana, where he worked in the dye house at the Woolen Mill. In this William Noé photograph from the 1930s, Kolb mixes chemicals.

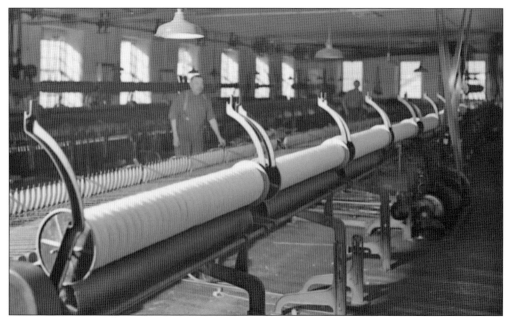

Gustav Hergert (1888–1942), standing at left, and a coworker pose with a spinning mule at the Amana Woolen Mill. As the frame of the machine moved back and forth, it spun the wool roving (wound on the long tubes at right) into yarn, which was automatically wound on the individual wooden quills, which would then be placed in bobbin carts and sent to the weaving department to be placed in shuttles for weaving.

When William Noé photographed the weaving department at the Amana Woolen Mill in the 1940s, the looms were still connected by drive shafts that could be powered both by the water turbines set in the millrace canal just outside the building or by the enormous steam engine whose smokestack dominated the Amana skyline.

William Noé photographed Ferdinand Goerler Sr. (1876–1947) threading warp into a loom at the Amana Woolen Mill. Goerler was a lifelong resident of Amana, except for a two-month absence in 1896 when he briefly left the society.

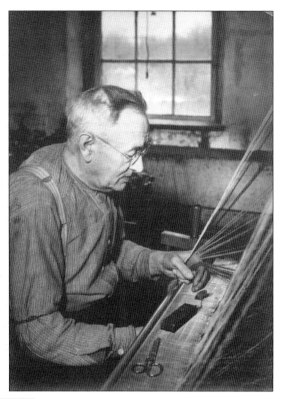

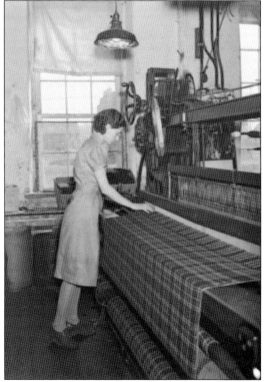

Verona Reihmann Schinnerling (1905–2001) began working the Middle Amana Woolen Mill soon after the 1932 reorganization. Later, she worked as a weaver at the Amana Woolen Mill, where William Noé photographed her tending a loom in the 1940s.

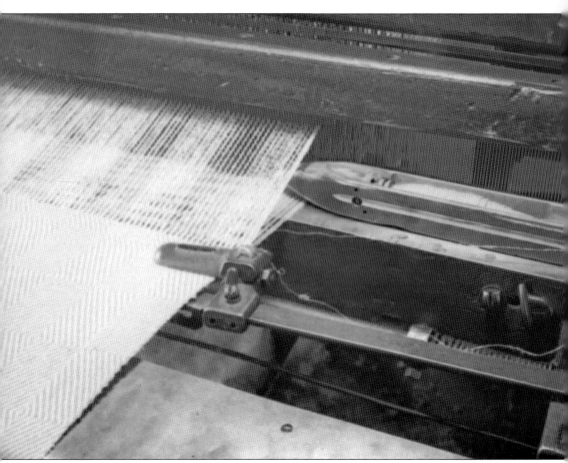

The metal-tipped wooden shuttles that carried quills of wool yarn across the loom during weaving could be hazardous. Shuttles occasionally flew off the loom, sometimes injuring workers.

This photograph of Phillip Dickel (1899–1981) oiling a machine at the Amana Woolen Mill illustrated a newspaper article about Amana Society wartime production in 1941. During the communal era, Dickel had been a basket maker. In the 1970s, he helped revive the craft of traditional willow basketry in the Amanas by teaching local artisan Joanna Schanz his techniques.

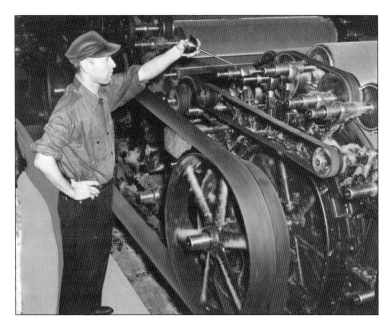

This photograph of the Amana Woolen weaving building all lit up for nighttime production was taken by William Noé in 1937 and appeared in the *Cedar Rapids Gazette* with a caption highlighting how increased demand meant that a night shift had been added at the mills. The photograph also celebrated the new electric lines that had been installed in Amana that spring.

Elsie Heinze Baust (1916–1994) was one of several women whose job was to inspect cloth, and when possible, fix broken threads in the finished wool products at the Amana Woolen Mill, where she posed for John Barry in 1937.

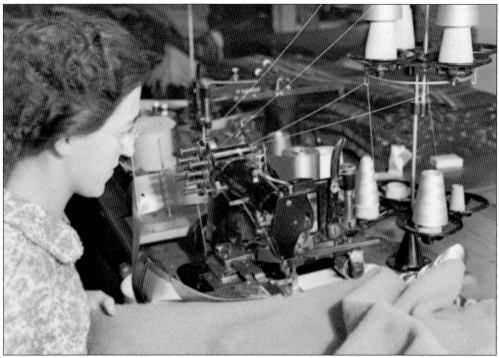

Helene Rohrbacher Leichsenring (1913–2006) began working at the Amana Woolen Mill as a young woman in the 1930s. For most of that time, she operated the same piece of equipment, the serger, which bound the edges of blankets. Leichsenring worked at the mill for over 70 years.

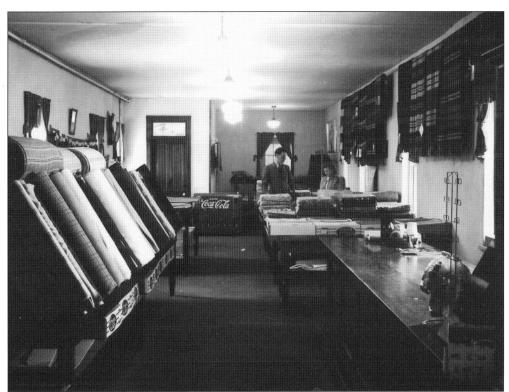

In the mid-1930s, the Amana Woolen Mill opened an on-site salesroom. Previously, the society sold woolen products locally only through the village stores. Under the management of John Reihman (1912–1986), the salesroom (seen here) occupied the narrow brick building that formerly housed the mill office. In the 1950s, sales were large enough to warrant the construction of a large salesroom.

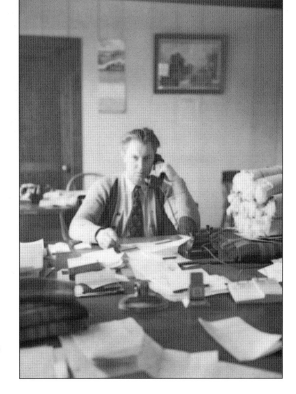

Adolph Heinze (1913–1990) had a long career as manager first of the Middle Amana and later, Amana Woolen Mills. Heinze became manager at Middle when only 22 years old. Here, he is seated at his desk in the mill office at Amana.

When John Barry took this portrait of her in 1937, Marie Stuck Selzer (1916–1999) worked as a tour guide at the Amana Woolen Mill. A popular activity for many Amana visitors was a guided tour through the factory, with a stop at the salesroom to purchase a blanket afterward.

John Barry photographed the Middle Amana Woolen Mill in 1937 when portions of the complex were already being used for a short-lived wood products shop under the management of L.J. Toogood, as well as the continued, but declining, production of woolen goods. By 1939, the society consolidated woolen operations at the Amana mill. This mill complex then became the main facility of the society's refrigeration department. Today, all that remains of the scene captured by Barry is the old mill smokestack.

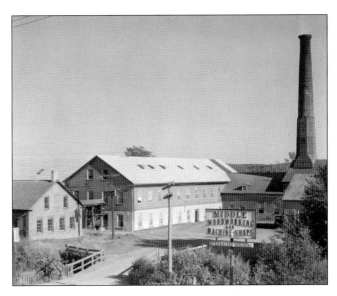

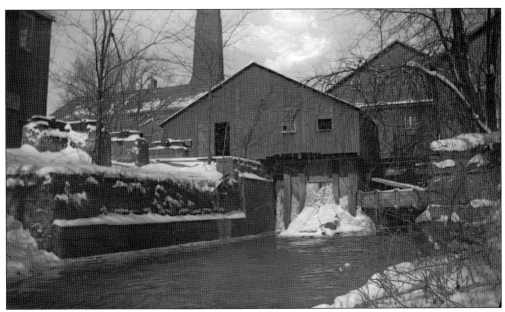

The Middle Amana Woolen Mill had essentially ceased operation when Rudolph Kellenberger photographed the millrace canal and the powerhouse containing the mill turbines in 1939. By 1943, these buildings had vanished as a result of a fire that destroyed the old factory buildings, then housing the Amana Society Electrical Department. Today, this site is completely covered by the buildings of the Amana Refrigeration Products division of the Whirlpool Corporation, the successor to Amana Refrigeration.

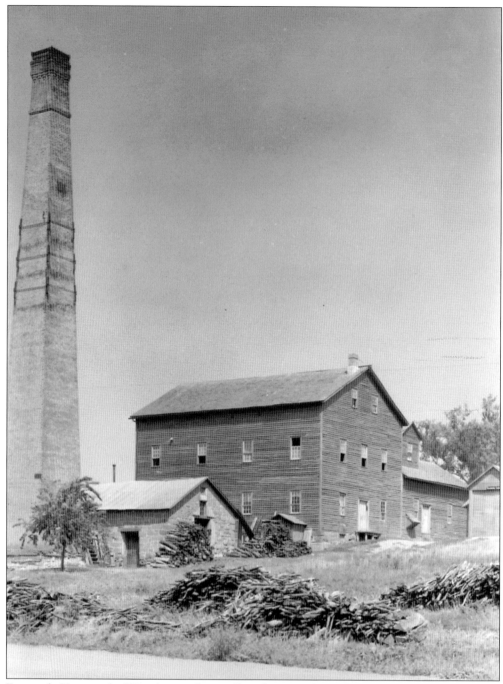

For nearly 80 years, the West Amana flour mill, with its 100-foot-tall smokestack, was the defining landmark of that village. Although still operating when photographed by Barry in August 1937, the flour mill soon closed and was demolished by the Amana Society.

Rudolph Kellenberger documented the demolition of the West Amana Flour mill smokestack in July 1939. Here workers from the firm responsible for demolition are seen placing charges in the base of the chimney.

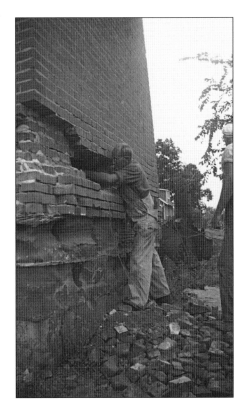

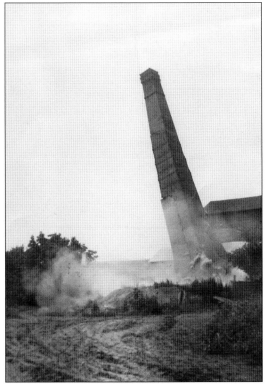

An unknown photographer caught the collapse of the chimney from another angle. The tower had been built by an outside contractor, Frederick Kye of Marengo. It was struck by lightning in 1895, which necessitated the reconstruction of the top 25 feet.

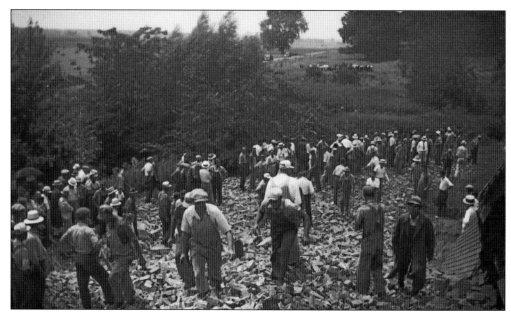

Onlookers swarmed over the ruins of the collapsed tower. One relic that survived the collapse was the iron "1874" numerals that had been mounted high atop the chimney. This item is now in the collection of the Amana Heritage Society.

This view of the village of High Amana was taken on August 22, 1907, the day that William Foerstner (1881–1974) and Christine Gernand (1887–1971) married in the High Amana Church. William Foerstner was an avid photographer and positioned his camera in an upstairs window of the church, instructing a friend to open the shutter to photograph friends and family as they walked to the service. In 1934, the small shed behind the house second from left in this photograph served as the first workshop for the Electrical Equipment Company of George C. Foerstner, William and Christine's son, which began operation in 1934.

The South Amana cabinet shop is pictured here some years before it housed the second production facility for the Electrical Equipment Company of George Foerstner. Employees crafted cooler doors inside this building. Because electricity had not yet come to the Amana villages, the electric saw and drills were powered by a generator.

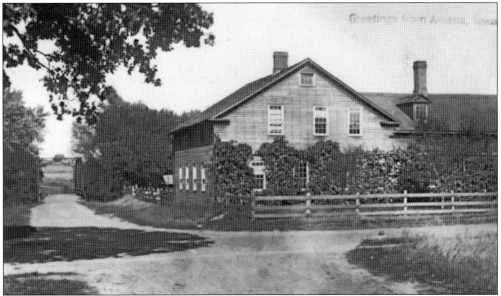

In 1936, Foerstner sold his company to the Amana Society, remaining as manager of the new electrical department. Following the purchase, the company moved into the vacant Amana cabinet shop, while manufacturing was located in the Middle Amana Woolen Mill. In 1941, the cabinet shop building burned to the ground, the first of two fires to strike the growing business during World War II.

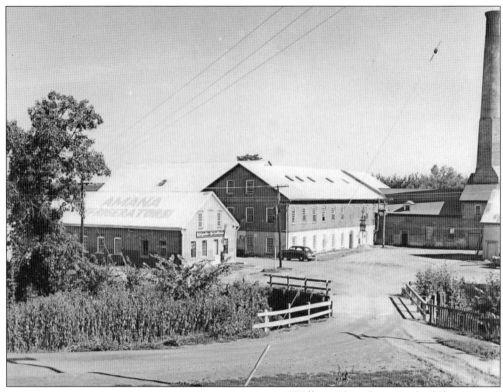

William Noé photographed the manufacturing facilities for the electrical department in the late 1930s soon after it had moved into the former Middle Amana Woolen Mill. The bridge in the foreground crosses the millrace, which, until only a few years before, had powered the woolen mill machinery.

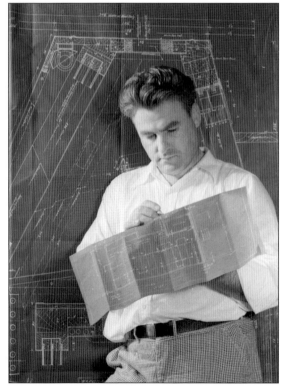

In August 1937, no one, including photographer John Barry, could have foreseen the phenomenal growth of the small appliance-manufacturing division of the Amana Society. Barry, who admittedly was trying to photograph traditional Amana, made only one photograph related to the appliance company, this portrait of Carl Flick (1904–1976) posed in front of a set of blueprints.

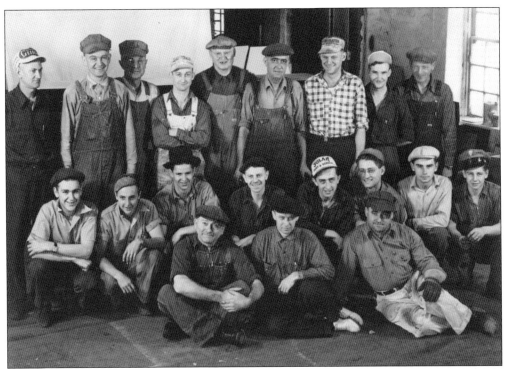

In July 1939, all 20 production employees of the refrigeration division posed for this group photograph. From left to right are (first row) John Schaefer (1888–1962), Fred Schneider (1901–1986), and Carl Flick (1904–1976); (second row) Clarence Ehrmann (1919–1975), George Mittelbach (1921–2015), Otto Puegner (1920–2003), George Bopp (1913–1966), Herbert Reihman (1915–2001) Carl Fels (1906–1960), Leroy Graesser (1921–2013), and Walter Seifert (1918–2002); (third row) Henry Fritsche (1887–1974), George Lippman (1908–2001), August Wendler, Skinny Primrose, George Zuber (1881–1972), John Blazek, Leonard Graf V (1911–1997), Walter Leichsenring (1918–1995), and Gottlieb Albrecht (1899–1970).

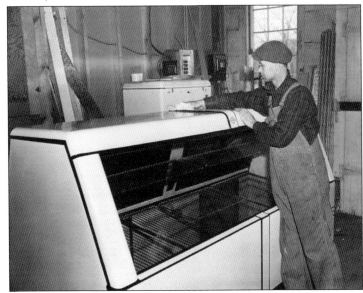

This 1939 press photograph, taken inside one of the early production facilities, possibly the former Amana cabinet shop, shows employee Fred H. Schneider (1901–1987) polishing a completed display cooler probably intended for a grocery or other retail business.

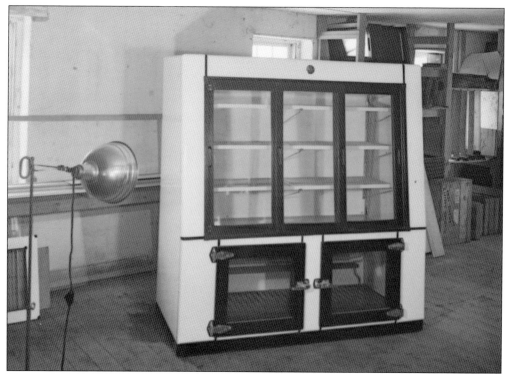

This is an uncropped photograph of an Amana cooler, taken by William Noé in the early days of Amana Refrigeration, possibly before World War II. The tremendous growth of this division during the war and the enormous demand for refrigerators and freezers led to complex advertising campaigns photographed and designed by professional agencies.

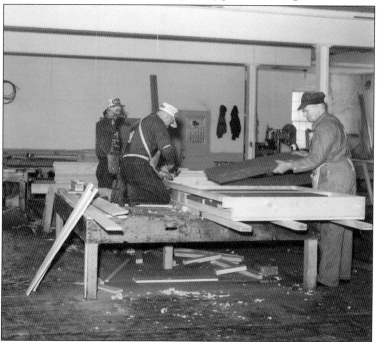

Workers at Amana Refrigeration are pictured here installing cork sheets into components of a cooler. The men are working in a converted building of the Middle Amana Woolen Mill. This photograph predates the 1943 fire, which destroyed most of the facility, including the wooden beams and interiors of the mill seen here.

Six

HOME AND LEISURE LIFE

The Great Change expanded the horizons of Amana residents. No longer restricted by the rules and regulations of the church elders and with income of their own, Amana residents were quick to remodel or modernize their homes, buy radios and automobiles, support new community clubs, and join in support of local baseball teams and community celebrations. Although Homestead residents had founded their Welfare Club in 1919, the reorganization opened the door for community clubs in the seven villages, including the Amana Community Club in West Amana, the Middle Progressive Club, the Amana Welfare Association, and the Amana Young Men's Bureau. Community members gave strong support to annual Fourth of July picnics and community pageants and plays, particularly those staged at the new high school.

Despite these new divisions, traditional leisure activities such as knitting, crocheting, quilting, woodworking, hunting, and fishing continued. Several residents became interested in the fine arts, an interest encouraged by artist Grant Wood (1891–1942) of Cedar Rapids, who was a regular Amana visitor. Wood fostered the talents of artists such as Carl Flick, John Eichacker, and George Schoenfelder and also encouraged residents to continue traditional crafts such as rug and carpet making and tin smithing. In 1932, Wood proposed that the society assemble a collection of traditional craft items that young people could study and copy in their own work. Wood's vision was finally realized in 1978, when residents formed an organization, the Amana Arts Guild, dedicated to documenting, preserving, and perpetuating traditional Amana crafts, many of which had been preserved through the decades by dedicated hobbyists.

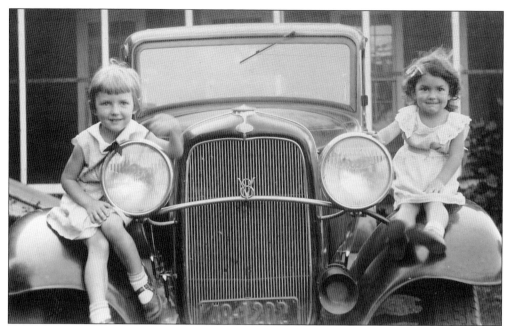

Homestead children Betty Jane Lipman (1929–), at left, and her sister Rose Marie (1931–) were photographed seated on a family automobile around 1934. The first large purchase made after the reorganization by many Amana families was an automobile. (Author's collection.)

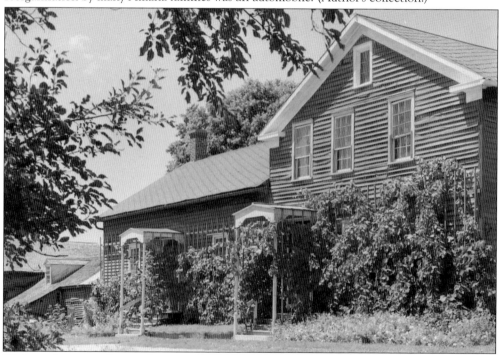

Within a few years of being photographed by John Barry, the unpainted siding on the former East Amana bakery was replaced with a modern commercial siding, as the structure was converted to a residence. The one-story section of the building at left dates from 1865, while the two-story section was erected in 1880.

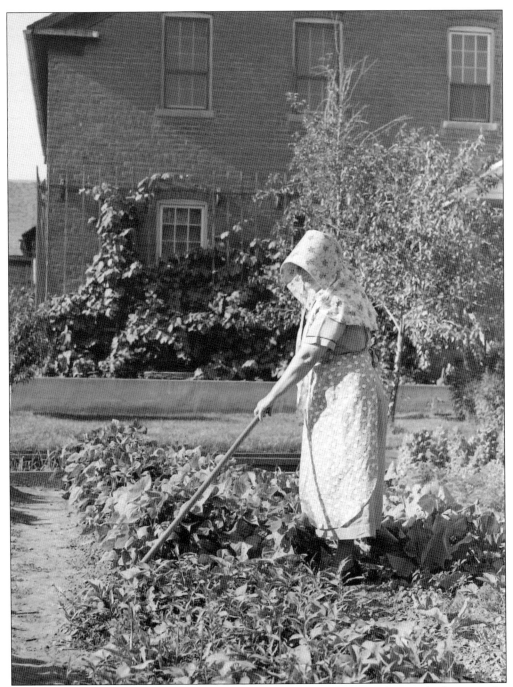

Lisette Baust (1877–1947) lived her entire life in the village of Amana, sharing the house in the background of this scene with her father and married sister. Baust never married. John Barry noted, "It took some doing" to convince her to pose, but she apparently entered into Barry's project with some gusto, as he went on to photograph her in three separate compositions. This portrait illustrated an Amana article in *Successful Farming Magazine* in November 1937.

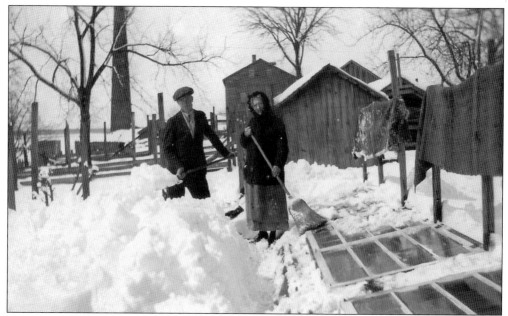

This photograph of West Amana schoolteacher Paul Kellenberger (1909–2003) and his mother, Clara (1879–1954), clearing snow from the windows covering their garden cold frames was taken by Paul's brother Rudolph around 1935. (Author's collection.)

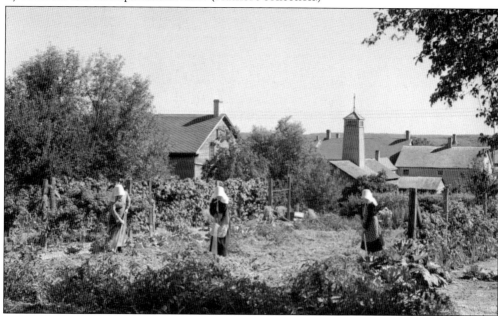

Although not individually identified, the three women seen here at work in an East Amana garden are Elisabeth Schaefer (1878–1948), her sister-in-law Lena (1877–1953), and her daughter-in-law Lydia (1900–1987). The tower housed the East Amana village bell, which was rung to call society members to mealtimes. This bell had originally been used in the village of Upper Eben-Ezer, New York, and was brought west when the Inspirationists moved to Iowa. Later it was given to the Amana Community School District, and is now housed in a small brick enclosure by the Amana Community Library.

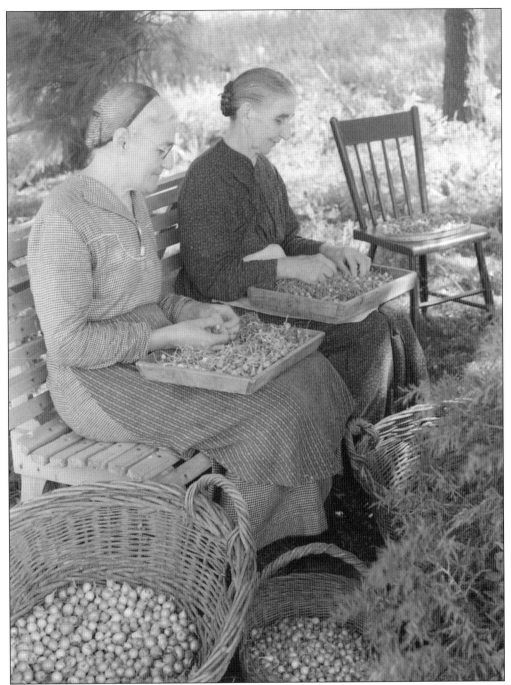

John Barry photographed Elisabeth (left) and Lena Schaefer sorting onions in lap boards. Barry recalled that a third woman did not wish to have her photograph taken, left her lap board on her chair, and walked out of the scene. The large willow baskets in the foreground were likely the work of East Amana's basket maker, Albin Werner (1861–1931).

Ida Leichsenring Hertel (1872–1960) was photographed sorting vegetables by her son-in-law, William Noé. Born in Germany, Hertel managed a communal kitchen in Amana prior to 1932 in the building occupied since 1950 by the Ox Yoke Inn Restaurant.

Like many Amana women in the 1930s, Lisette Baust wore a sunbonnet when she worked in the garden in front of her family home, as photographed by John Barry in August 1937. The image of Amana women with bonnets was so deeply ingrained that the Amana Society included one in its corporate logo.

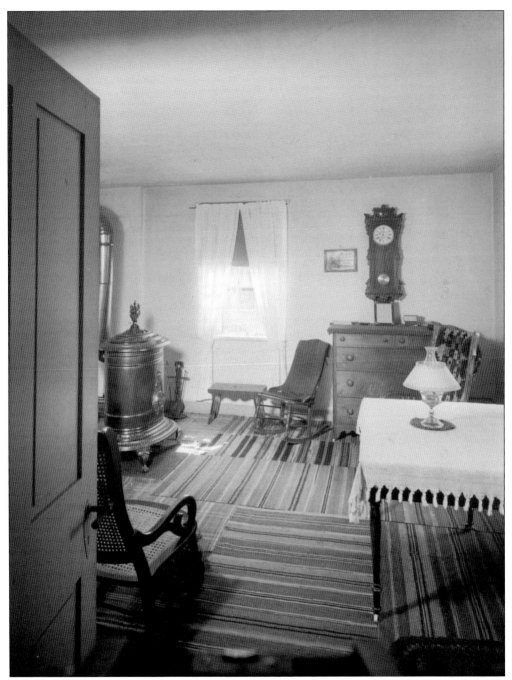

This study of an Amana parlor was taken by John Barry in August 1937 and captures elements that were typical of most Amana homes during the communal era and in the years immediately following. The walls were probably still covered with the light blue whitewash used in all communal-era interior spaces. Amana homes were heated with wood-burning stoves and had floors covered with strips of woven rag carpets sewn together and tacked along the walls. All of the furniture, with the exception of the wall clock pictured, was made in Amana. The distinctive lever latch on the door and even the heavy paper shade on the lamp sitting on the table were Amana-made.

This scene, which photographer John Barry titled "Behind the Stove," shows the usual stove-tending paraphernalia that was still in use in most Amana homes in 1937. The local farm department was charged with cutting wood for winter use, and each family received an allotment each fall that was meant to meet their winter heating needs. Within a decade of this photograph, most Amana homes converted to oil- or coal-fired furnace systems.

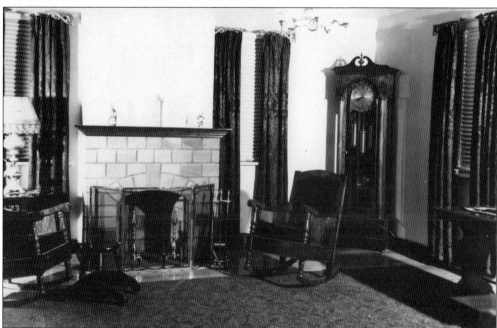

Harry Schaefer (1901–1951) purchased the East Amana Butcher Shop after the 1932 reorganization, when the Amana Society consolidated the butchering operations at East and Main Amana into one location. This photograph, taken by William Noé, was included in a story about the remodeling that appeared in the *Cedar Rapids Gazette* of December 17, 1939.

This enormous Main Amana residence had served as a communal kitchen until the reorganization of 1932. The stone used to build this structure was, according to tradition, bought from a quarry in Iowa City. It is much more carefully shaped than the rough stone found in most Amana buildings. In 1937, when photographed by John Barry, the structure was home to members of the extended Moser family. Jacob Clemens (1898–1943) used a portion of the old kitchen house wing, at left, for his watch-repair shop, as advertised by the sign above the porch.

The 1904 house occupied by South Amana service station manager Fred Setzer (1892–1973) and his family was photographed by John Barry in August 1937. Setzer's young daughter Emily Jane Setzer Shoup (1933–2002) stands in the doorway. Within a few years, the Setzers remodeled the home, bricking over the doorway in which Emily stands.

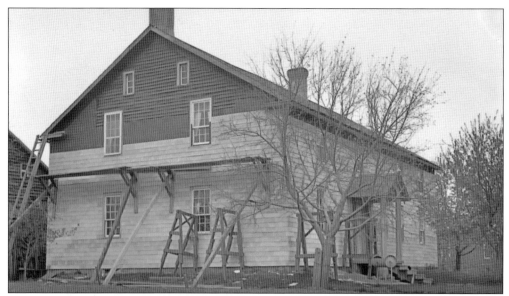

William Noé photographed modern asbestos shingle siding being applied to the Moessner family home in the village of Middle Amana in 1933. The siding was still in place in 2015. In 1936, Richard Roberts counted 70 houses in the seven villages that had been covered with this type of siding, which was either brown or gray in color, with gray being the most popular choice.

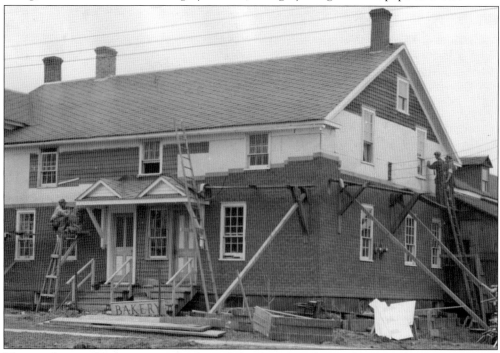

The simple sign that hung over the door of the Amana Bakery is lying on the ground in this photograph of the bakery's original wood siding being covered with asphalt and tar paper siding in April 1937. This type of siding was cheap, durable, and very popular in the Amanas during the 1930s. Ironically, a later owner restored the original wood siding to this structure, which now houses the Ackerman Winery.

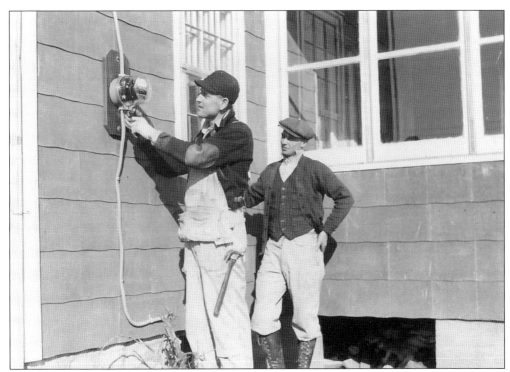

The Amana Society was quick to take advantage of the funds provided by the Rural Electrification Administration when that New Deal agency went into operation in 1936. A $25,000 REA loan paid for the installation of 23 miles of electric lines within the Amana villages. Seth L. Larson (1904–1937), pictured here with his assistant Fred Hess (1916–1937) of East Amana, was the first lineman for the new Amana Society Service Company. In this capacity, Larson, a nonmember of the society who lived in West Amana with his wife and young son, installed electric lines and meters in the villages. This February 1937 photograph of the two men illustrated a *Cedar Rapids Gazette* article on Amana electrification. Tragically, both men died as the result of an accident at a railroad crossing on April 27, 1937, barely two months after this photograph was taken.

When the initial Amana electric lines were in place, the honor of symbolically throwing the switch fell to assistant Amana Society corporate secretary Charles Eichacker (1909–1984). Pictured here are, from left to right, Earle Nichols (division manager of Iowa Electric Light and Power Company), Eichacker, Peter Stuck (Amana Society secretary), and Allen Hurd (superintendent of the new power division). The first switch was thrown on February 25, and the full power load started on March 4.

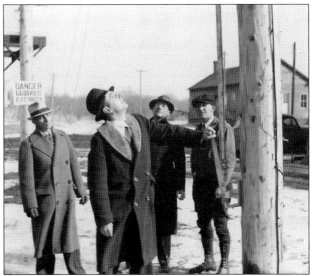

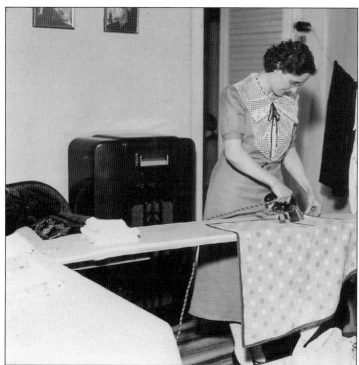

Erna Jeck Noé Conrow
(1905–1992) poses for
a press photographer
demonstrating her
electric iron and
new electric radio
in February 1937.

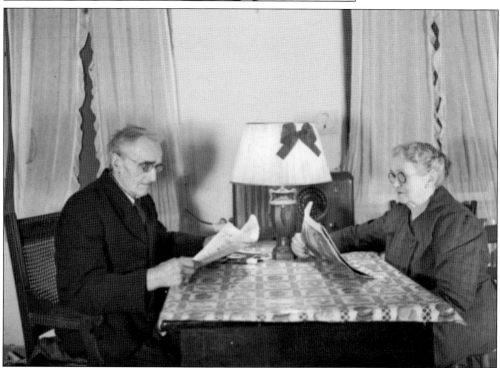

Louis (1861–1938) and Maria (1869–1955) Krauss were among many Amana residents who posed
for press photographers at the time that electricity was introduced to the villages in February
1937. Here the couple read by electric light beside their electric radio.

Louise Hahn Rettig (1872–1957) and her daughter Louise Rettig Geiger (1896–1956) happily pose with their new Maytag washing machine in the basement of the Geiger home for a *Cedar Rapids Gazette* photographer in February 1937.

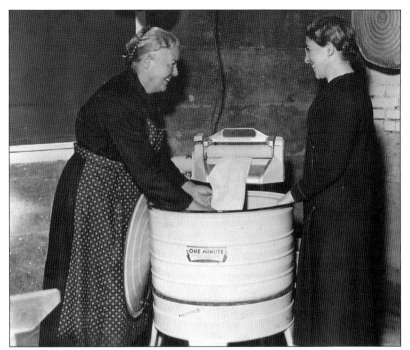

In 1938, Phillip (1897–1991) and Clara Leichsenring Mittelbach (1897–1992) built a new home on the edge of South Amana. This was the first new home to be built after the reorganization, and as such, the construction warranted regional newspaper coverage. The Mittelbach home was a thoroughly modern structure, with no hint of traditional Amana design in its construction.

Emily Jane Setzer Shoup (1933–2002) was the youngest Amana resident to pose for John Barry during his visits in 1937. The Setzers lived in Upper South Amana, a small enclave of houses, a hotel, general store, and a depot that the Amana Society began building in 1883 in order to serve travelers on the Chicago, Milwaukee & St. Paul Railroad.

Carl Albert (left) and William "Bill" Ackerman were hauling lunch to their fathers at the Amana Woolen Mill when John Barry photographed them pulling a coaster wagon in Amana. The boys are walking along what is today known as 47th Avenue, the diagonal street that connects the woolen mill to the main section of the village of Amana.

William Noé photographed Pauline Bahndorf (pictured) and her sister Lina Trumpold in January 1939. Both women posed by the same window and table while doing some form of handwork, in this case, braiding corn husks for stitching into a floor mat. Bahndorf (1858–1947) never married and lived above the kitchen house that her sister managed in East Amana. (Author's collection.)

Lina Bahndorf Trumpold (1867–1945) had been a communal kitchen boss. In 1939, she posed for William Noé while picking nut meats from black walnuts. Trumpold dressed in her church clothes for the photograph. (Author's collection.)

William Heinze (1855–1944) of Middle Amana demonstrates his antique zündt machine for photographer William Noé in 1938. This unique form of lighter, developed in Germany in the 1830s, was filled with a mixture of water and sulphuric acid. Through a chemical reaction, the machine produced a flame when a lever was moved. This device fell out of use with the introduction of the friction match, although people in Amana continued to use them into the 20th century. Heinze here demonstrates how a piece of kindling was used to transfer the flame to his cigar. Heinze was born in Lower Eben-Ezer and came to live in Middle Amana when there were only three houses there. Heinze worked as a printer, was a schoolteacher from 1874 to 1880, and held various other occupations during his long life.

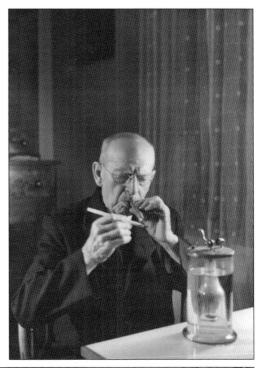

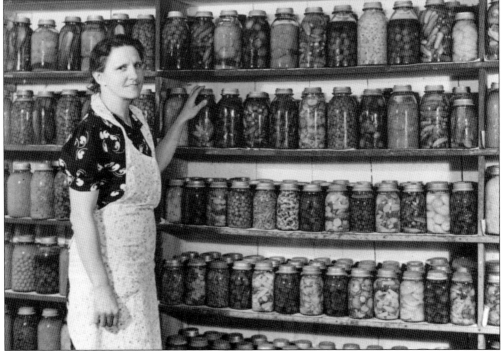

With the end of communal living, Amana families had to prepare food in their own kitchens for the first time. Most families planted enormous vegetable gardens. Magdalena "Leni" Oehl Schuerer (1900–1998) proudly displays the summer canning stored in her East Amana home for photographer William Noé around 1940.

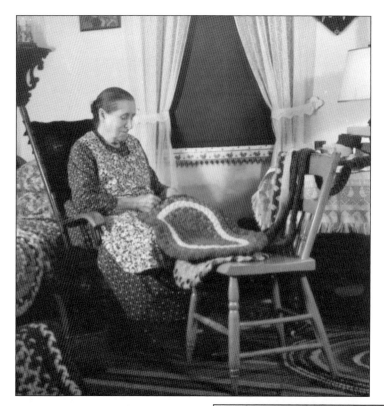

Carolina Schaup Setzer (1862–1955) was a lifelong resident of South Amana. William Noé photographed her crocheting rugs in the late 1930s. Setzer was well known for her handwork, including needlepoint.

During the communal era, Louise Hahn Rettig (1872–1957) instructed Middle Amana children in the art of knitting and crocheting during the time designated for that craft each day at school. She was beloved by local children for her stories and the paper cutouts and crocheted animals she made for them. Rettig would ask a child what animal they would like, and without a pattern, would crochet the animal from yarn. Her more elaborate work included entire miniature Christmas trees, decorated with ornaments and candles, all made from yarn. Rettig also was known for making pictures from dried seeds and plants. William Noé photographed Rettig at work in the 1930s.

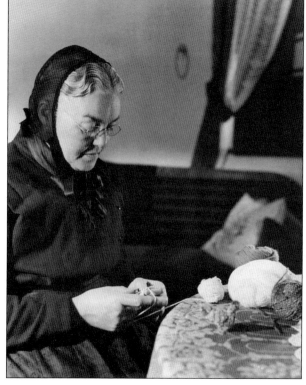

West Amana store worker Carl Flick began painting in 1927 and soon contacted Grant Wood (1891–1942), a then-unknown Cedar Rapids artist, for painting advice. The two became close friends. Wood encouraged Flick to paint local Amana scenes, accompanied him on sketching trips around the villages, and arranged for the exhibition of Flick's work. William Noé captured Flick painting outdoors in Amana in this portrait from about 1936. Like his mentor, Grant Wood, Flick often painted plein air oil sketches in the field.

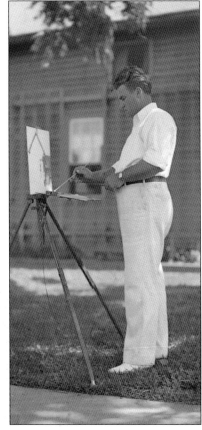

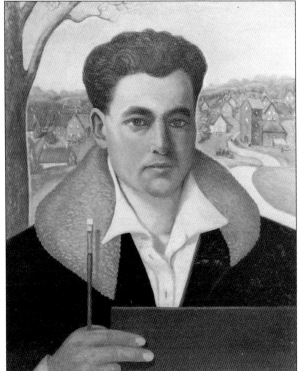

Flick's 1932 self-portrait was completed for an exhibition sponsored by the Iowa Federation of Women's Clubs. While the background scene of his home village of West Amana is by Flick, the finely rendered figure suggests that Wood worked with his protégé on the piece. Flick never painted another portrait. This photograph of the self-portrait was taken by John Barry on a return visit to the Amanas in 1947.

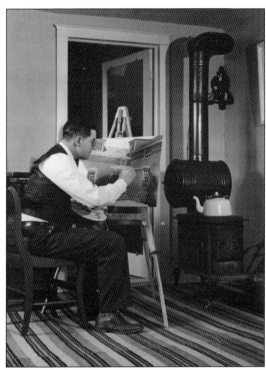

John A. Noé (1900–1954) was the second Amana painter to gain wider recognition in the two decades following the reorganization. An accountant and manager, he began painting in 1942, usually indoors because of his concern of what his neighbors would think of his hobby. Noé exhibited widely and received awards and recognition before his untimely death. Although unmarked, this photograph is likely the work of Noé's brother William. (Author's collection.)

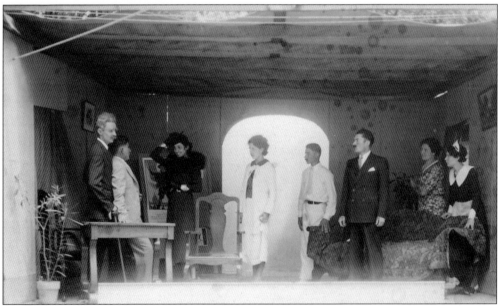

Pictured here is a scene from the play *Here Comes Charlie!* performed by young members of the Homestead Welfare Club. Started in 1919 during the communal era, the club was intended as a social outlet for residents of the village of Homestead. Soon, however, the club began to organize its members for community-improvement projects, such as creating an ice pond for the village's use, and in later years, paving the village's lone street, establishing a sewer system, and always and foremost, sponsoring town picnics, sporting events, and entertainment such as the play pictured here. (Author's collection.)

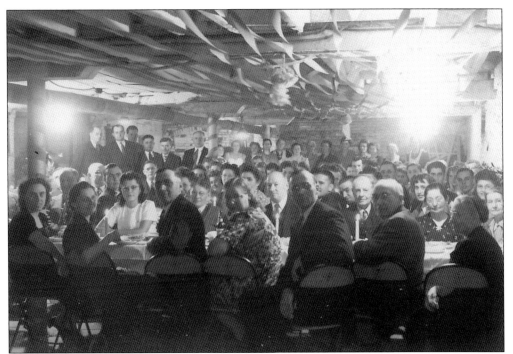

In 1944, members of the Homestead Welfare Club gathered to celebrate its 25th anniversary, hiring photographer H.W. Swift to document the event. For the occasion, the club, which had relocated to a new building years before, returned to its original meeting room in the basement of the Homestead Church. In 1931, this space had also served as the meeting place for the committee that planned the Amana reorganization. (Author's collection.)

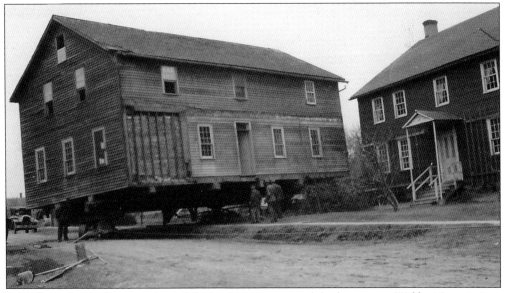

In 1933, residents of Amana formed their own community club, the Amana Welfare Association. In March 1934, the club purchased the wing of the Leichsenring family home that had served as a communal kitchen prior to 1932. The wing was separated from the building and moved approximately half a block to serve as a clubhouse. (Author's collection.)

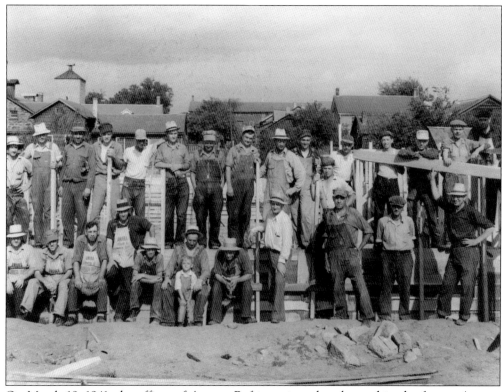

On March 19, 1941, the offices of Amana Refrigeration, then located in the former Amana cabinet shop, burned to the ground, possibly as the result of arson. The fire spread to the Amana Welfare Association Clubhouse and destroyed that building, which the club had moved to the site only a few years before. Here a large group of club members and others pose while constructing a replacement clubhouse. That structure still stands and today is an antique mall.

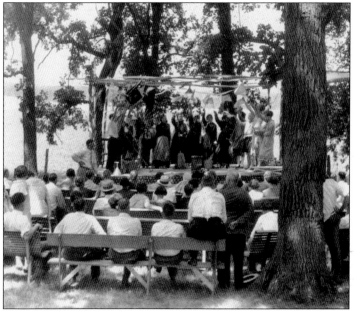

This photograph shows a Fourth of July program at Middle Amana in the mid-1930s. Fourth of July celebrations were held in oak groves near Middle Amana, Amana, and Homestead. In recent years, a modern revival of the Amana Fourth of July celebration has been held in the oak grove at Middle Amana, pictured here. Such gatherings in the Amana villages often featured guest speakers, and after nightfall, movies.

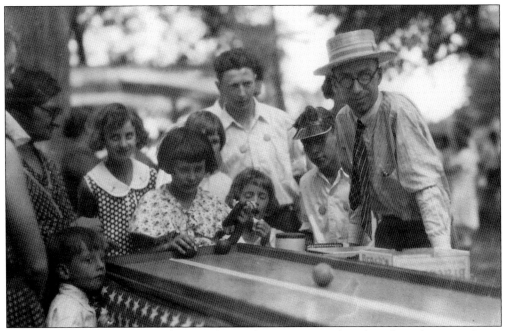

Henry Klipfel (1877–1947), in glasses and straw boater, is remembered as always being in charge of this bowling game at the Amana Independence Day celebration. Apparently, the prize for this game was Brach's candy.

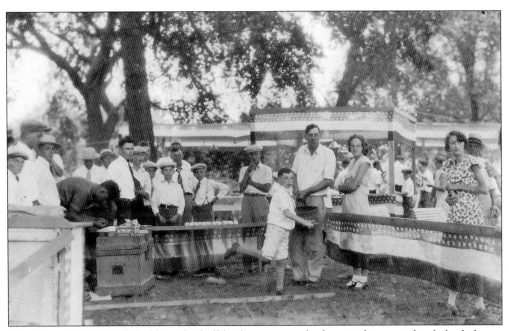

John Hass (1900–1956), holding the ball basket next to the boy pitching, evidently had charge of the dunk tank at the Amana Independence Day celebration in this late 1930s photograph by William Noé.

Peter Stuck took this photograph of the Independence Day celebration grounds in an oak grove north of Amana reached by crossing a makeshift, but festively decorated, bridge over Price Creek. (Author's collection.)

This bowling game at the Amana Independence Day Celebration in the late 1930s was photographed by William Noé. Bowling, dunk tanks, and games of chance, so much a part of the fun at these celebrations, were unknown in communal Amana just a few years before.

Seven

THE AMANA SCHOOLS

Even during the communal era, the Amana Schools were always public schools under the supervision of the county superintendent of schools. Originally, Amana schools followed the German *Volkschule* pattern of classroom time interspersed with work hours—during which all children learned to knit or helped in the orchards or gardens—and play time.

As Iowa school regulations became more stringent, the Amana schools changed to accommodate them, sending promising young men away for formal teacher training and eventually becoming similar to other rural schools of the 1920s.

Following the 1932 reorganization, the Amana schools became a community school district. The village schools continued to teach students through eighth grade. In 1932, Amana students who wanted to attend high school commuted to the neighboring towns of Williamsburg and Marengo.

In 1934, the district added 9th and 10th grade and soon expanded to a full high school program, graduating its first class in 1936. During the 1940s, the primary grades from all seven villages consolidated in particular villages: the lower elementary grades were taught in South Amana, upper elementary at Amana, and junior high at Middle Amana.

In 1954, the district built a modern school building in Middle Amana to house the elementary students from all seven villages. Later additions expanded the building into a kindergarten through high school facility. The Amana Community Schools merged with the neighboring Clear Creek Community School District in 1995.

During 1934, the Amana Society and the schools encouraged the formation of two Amana Boy Scout troops and an organization known as the Girl Reserves for the teenage youth of the community.

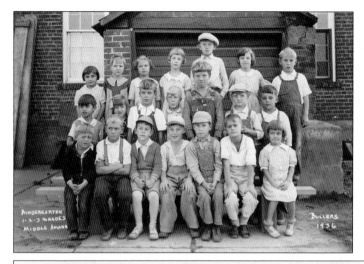

This 1936 photograph is of children in the first through third grades posed outside the Middle Amana schoolhouse. The children are sitting and standing on benches arranged by the entrance to the schoolhouse cellar. (Author's collection.)

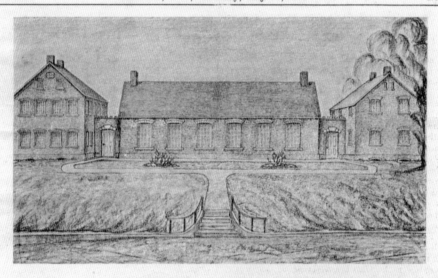

AMANA SOCIETY BULLETIN

Vol. IV Amana, Iowa, Thursday, May 30, 1935 No. 4

The New School Addition

This is a picture of the proposed modern school plant for Amana. It represents the combined, careful, and reasoned conclusion of educators, architects, and local committees. The State Department of Education was the first to be consulted, then the ex-

Die Vergrößerung der Schule.

Dieses ist ein Bild des vorgeschlagenen modernen Schulgebäudes für Amana. Es repräsentiert das sorgfältig zusammen ausgearbeitete Gutachten von Lehrern, Baumeistern und lokalen Komittees. Das Staatsdepartment of Education wurde zuerst zu Rat gezogen

In 1935, Amana residents approved a $16,500 bond issue to convert the Middle Amana schoolhouse (left) and a residence (right) into a high school by raising the roofs of both buildings to provide a full second story and connecting them with a brick auditorium (built during summer 1935 with seating for 400) sympathetic in design to traditional Amana architecture. A drawing of the proposed high school, by Carl Flick, accompanied an article in the *Amana Society Bulletin*. To ensure that older voters in the district understood the proposal, it appeared in both German and English. (Author's collection.)

108

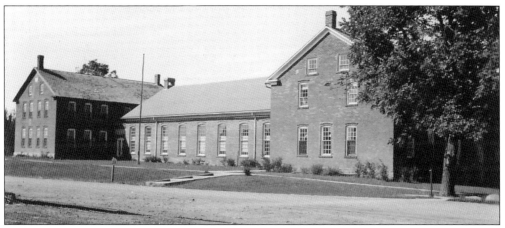

Paul Kellenberger took this photograph of the Amana High School around 1937. In this view, it is easy to see how the communal-era schoolhouse (left) and residence (right) were remodeled for classroom space, with a new auditorium connecting the two structures.

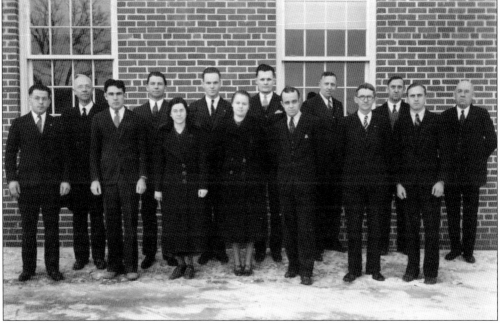

The Amana school district faculty gathered for this group portrait in front of the new high school auditorium during the winter of 1934–1935. The teachers gathered include the elementary teachers, who conducted schools in the individual villages, as well as the junior and senior high school staff. Pictured are, from left to right, (first row) Rudolph Blechschmidt (1903–1990), Howard Durner, Cledythe Fiser Roth (1906–1982), Francis Hartley, Adolph T. Berger (1908–1996), Fred Schaedlich (1892–1953), and Alvin Skow; (second row) Supt. John Ruskin Neveln, Carl Fels (1906–1960), Paul Kellenberger, Charles L. Selzer (1914–1988), F. Pitz, William Heinze (1890–1960), and Ludwig Unglenk Sr. (1869–1941).

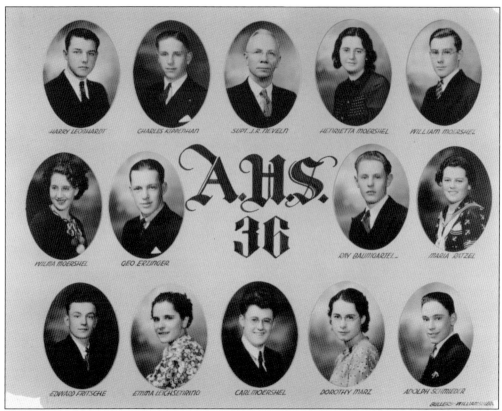

The Amana High School class of 1936 was the first to graduate from the new high school. This composite photograph of class members was assembled by Bullers studio of Williamsburg. The class of 1991 was the last to graduate from the high school. All of the school composite photographs hang in the hallway of the Amana Elementary School today.

The Amana High School offered a single competitive sport, baseball. Here, the 1942 high school team poses in front of the high school auditorium. Baseball was enormously popular in Amana, and several of the villages fielded their own teams. Several Amana men played semiprofessional ball, and one, Bill Zuber of Middle Amana, had a long professional career, playing for the Cleveland Indians, Washington Senators, New York Yankees, and Boston Red Sox.

In the early 1940s the Amana schools began a hot lunch program. Each day, two boys were dispatched by their teacher to bring a large kettle of soup from the kitchen of whichever Middle Amana woman was assigned to prepare it that day. William Noé photographed a junior high class at Middle Amana eating lunch at their desks in 1943.

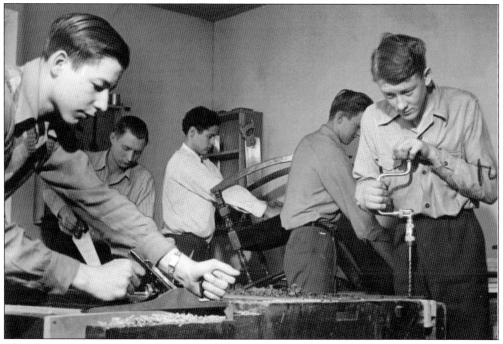

This photograph of high school students in a manual-training class illustrated a 1943 article in the *Des Moines Register and Tribune*. Pictured here are, from left to right, Harold Schuerer (1926–2015), Kenneth Schaeffer (1926–2012), two unidentified boys, and Raymond Seifert.

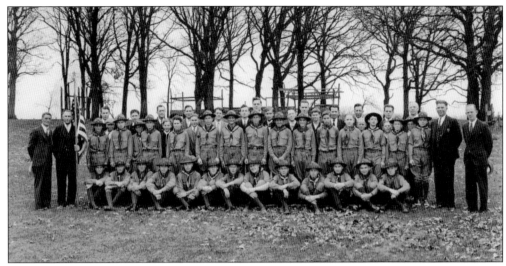

In early 1934, the Amana Society's board of directors agreed to sponsor a Boy Scout troop. The organizational meeting for the new Amana Troops 22 and 24 (later combined as Troop 223) was held on July 31, 1934, at the Middle Amana schoolhouse. Over 50 Amana boys ages 12 to 18 signed up to participate. The troop was under the leadership of Alvin Skow, who had been hired to teach at the new Amana High School largely based on his previous experience with scouting. (Author's collection.)

These Amana Boy Scouts, Reynold Hertel (1928–2015), William J. Noé (1926–2006), and John Berger (1927–1966), enjoy strawberry shortcake during a campout in June 1941.

Eight

TOURISM

The Amana villages were an object of curiosity for outsiders almost from the beginning of their settlement in the 1850s. Published accounts of the colonies began appearing during the Civil War and increased as railroad service connected the villages with the outside world. With the arrival of the railroads, the society built hotels in the villages of Homestead, South Amana, Upper South Amana, and Amana to serve visitors. During the communal era, the society elders were wary of the influence of outsiders, particularly on the youth.

With the coming of the automobile in the early 1900s, the stream of visitors continued to grow. In 1931, one writer reported that in one month, 3,000 visitors walked through the Amana woolen mills.

With reorganization, leaders of the new Amana Society grasped the benefits of encouraging the visitor trade. One of the first actions of the new corporation was to plan for gas stations at Homestead and Amana (a station at South Amana opened in 1928) and sandwich shops in Amana, Homestead, and South Amana. Tourist-oriented publications followed—the first brochure with a map of the villages appeared around 1933, and in 1935 the society assembled a booklet of photographs and text to showcase the villages, local crafts and products, and visitor services. Two restaurants, the Colony Inn and the Ox Yoke Inn, opened in the village of Amana in 1935 and 1940, respectively. After World War II, they were followed by Zuber's Restaurant in Homestead, the Ronneburg Restaurant in Amana, and, several years later, the Colony Market Place in South Amana and the Barn and the Brick Haus Restaurants in Amana.

Amana residents discovered that there was a market for items such as traditional German wine and handicrafts. In 1934, the first Amana winery, Ehrle Brothers, opened in Homestead. World War II slowed tourism, but it expanded greatly between the 1950s and 1980s, fueled by the name recognition brought by the popularity of Amana appliances. Tourism remains an important component of economic and cultural life in the villages today.

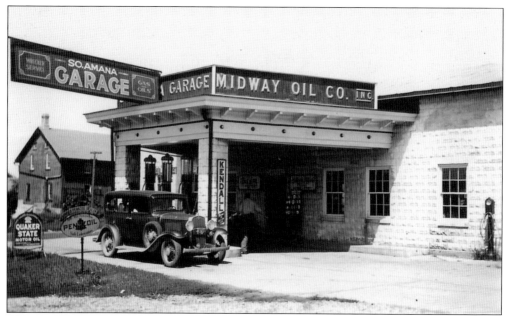

The Amana Society constructed the South Amana gas and service station in 1928. Unlike the stations that the society built in 1932, this example did not follow traditional Amana architecture. The station was managed by Fred Setzer (1892–1973) and served travelers on US Highway 6. Paul Kellenberger took this photograph on August 8, 1937. The projecting canopy has long since been removed, but the station continues to operate today as an automobile repair shop.

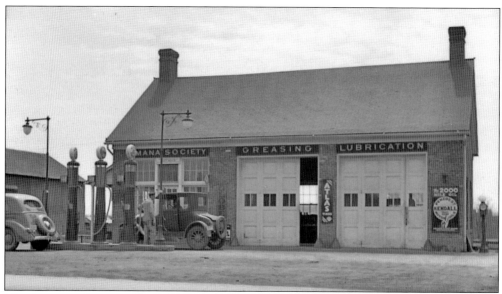

The Amana and Homestead stations were both built in 1932 with brick salvaged from the Amana calico mill. Originally, society leaders planned modern station buildings. Business manager Arthur Barlow, however, cautioned them to maintain the unique architectural style of the villages, use salvaged brick, and design the stations in the style of Amana houses. The Homestead gas station, seen here in a photograph by William Noé, remained in operation through the 1990s, and presently serves as a retail store.

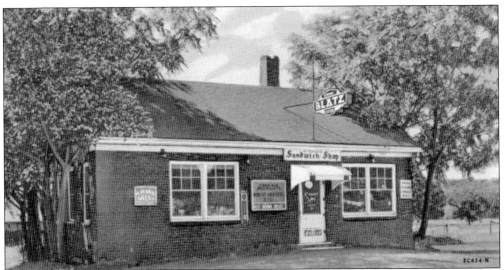

Sandwich shops operated next to the Amana, Homestead, and South Amana gas stations. The sandwich shop at Amana was only in operation for a few years. In July 1937, the *Amana Society Bulletin* reported that entertainer Cab Calloway and his orchestra had "regaled themselves with the good sandwiches and ice cold drinks served there." The visits of other notable travelers, including Katharine Hepburn, foreign visitors, and other interesting people, were routinely noted in the pages of the *Bulletin*. The Homestead sandwich shop (pictured) not only served food, beer, and other refreshments to travelers but also marketed Amana products such as blankets, furniture, bread, and meat. (Author's collection.)

John Eichacker (1910–1945) of Homestead aspired to become a commercial artist until the death of his father in 1935 and the need to support his elderly mother ended those dreams. Eichacker did various commercial assignments for Amana businesses, however, such as painting billboards. Eichacker painted this billboard with help from Albert Fels (1909–1979), who is pictured standing beside it around 1933. Eichacker painted most of his sign panels as they leaned against a large tree in his back yard.

In 1860, the Amana Society built the frame portion of this structure as the Amana Hotel. The hotel served the needs of visitors throughout the communal era, including farm families who came to Amana to sell wool to the nearby woolen mill or shop at the general store. In 1935, Jacob Roemig (1893–1978) purchased the building and converted it into a German-style restaurant, the Colony Inn, which became known for its family-style dining, in which patrons ordered an entree and then shared bowls of mashed potatoes, beans, sauerkraut, corn, and other side dishes with others at their table. The inn opened with a big party for local residents on November 21, 1935. Dinners in the early years cost 50¢ and always included dessert. There were no printed menus; servers recited the entrees available each day, until the first menus appeared in the early 1980s. The restaurant also housed, at various times, a beauty shop and slot machines. (Author's collection.)

John Eichacker produced this billboard for the new Colony Inn around 1936. Here, his nieces Betty Jane Lipman (left) and Rosemarie Lipman McGowan pose with the completed sign.

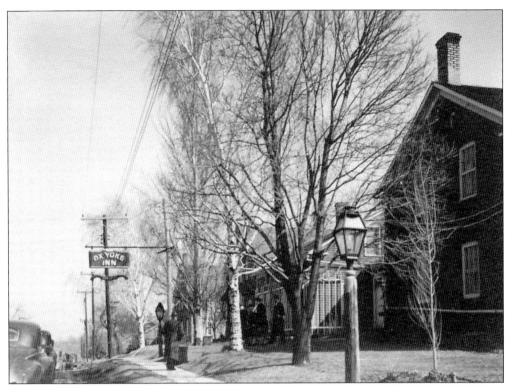

This photograph of the Ox Yoke Inn was taken around 1941 and shows the original sign with the wooden ox yoke for which the restaurant had been named by founders William (1908–2003) and Lina Leichsenring (1912–2001). In 1950, the restaurant moved into the building next door, and the location pictured here became the Ronneburg Restaurant.

In 1936, the Amana Society published this booklet, illustrated with historical and contemporary photographs of the community and its products as well as a brief history and description of the society and the community as it was four years after the end of communal life. The cover drawing, by Carl Flick, depicts the Middle Amana woolen mill. The title of this booklet notes that the society practiced "modified capitalism," reflecting that, although the society was a for-profit corporation, it was essentially a cooperative in which almost every worker also was a shareholder, entitled not only to dividends but to benefits, including payment of medical and burial expenses.

A unique landscape feature of the Amana villages for nearly 140 years has been the Lily Lake, a pond between the villages of Amana and Middle Amana. The 160 acres covered by the pond were originally marshland but by the 1870s had flooded into a pond. In the late 1880s, yellow American lotus plants grew and soon covered the lake. By the 1920s, the annual display of blooms attracted curious visitors from the surrounding area. In this August 1937 photograph by John Barry, Middle Amana resident Rudolph Trumpold (1901–1974) poses with a bundle of lotus blossoms.

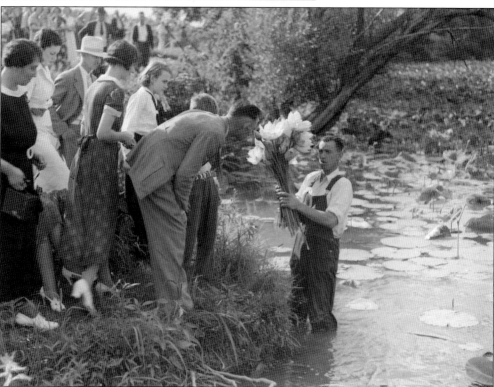

In this photograph, Trumpold hands the lilies to waiting visitors on the shore. For decades, children from the villages of Amana and Middle Amana made pocket money by setting up stands and selling lilies to visitors. Sales competition was fierce, and more aggressive young merchants were known to flag down passing cars in an attempt to convince the motorists of their need to buy a few blossoms to take home.

Nine

THE SECOND WORLD WAR

World War II was a transformative event for the United States, but the changes brought by the war were especially significant for the Amana villages. The war began just less than a decade after the society reorganized from communal life, and in many ways completed the process of transitioning.

Economically, the war affected the Amana Society in several significant ways. The war meant calls for increased crop production at a time when many Amana farm workers were away serving in the military. As a result, the move towards mechanizing the Amana farms accelerated. The woolen mills operated on a three-shift basis in order to fulfill government contracts, including flannel for uniforms for the US Army and its ally, the Soviet Union. The electrical department also fulfilled large government contracts for coolers, necessitating the rapid expansion of both workforce and facility. Two fires, in 1941 and 1943, temporarily slowed but did not stop the electrical department's production, which was twice recognized with Army-Navy E Awards.

Approximately 160 Amana men and two women served in the armed forces, a large percentage of the working-age Amana population. Four Amana men died while in the service. Finally, an entire generation of Amana men and women were exposed to the world beyond the colonies in new ways that shaped their thinking and their plans for the future.

The community to which they returned after the war was no longer the sleepy farming community of the 1930s. As the consumer boom of the postwar years exploded, tourism to the colonies increased, and Amana Refrigeration, a separate company after 1950, became a major national appliance brand. Many of the returning veterans built new tract homes on the sites of former communal gardens. While still distinctive, Amana villages acquired many of the features of the world beyond its borders.

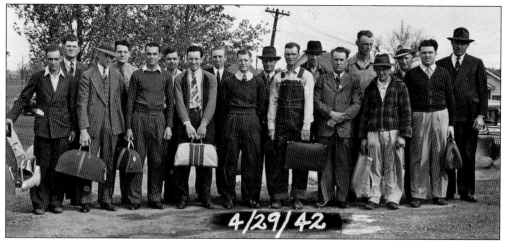

On April 29, 1942, several Amana men were included in this group photograph by Marengo photographer H.W. Swift before they left for induction into the US military.

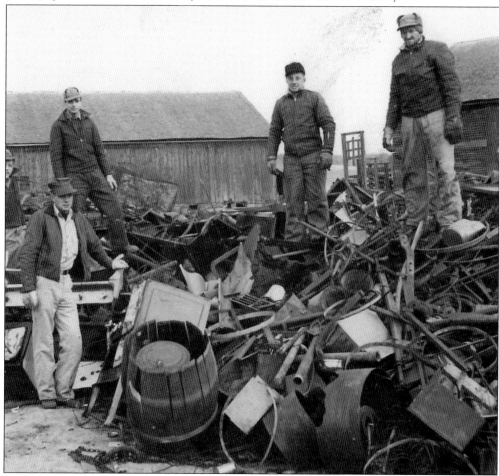

Like many other small communities, the Amana villages contributed to the war effort in numerous ways. Here, some Amana men are seen with material collected during a wartime scrap drive.

Amana school students were also involved in the war effort. Here, members of the Girl Reserves pose with a pile of stockings that they had collected during a drive.

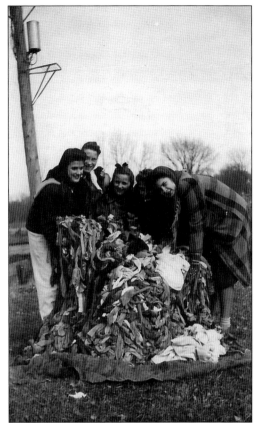

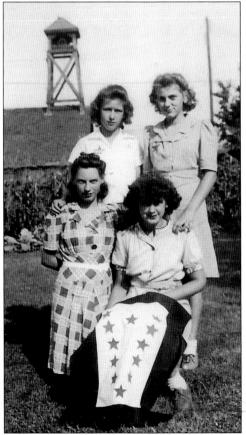

Members of the Girl Reserves worked to create a service flag for the Amana Welfare Association, with stars indicating each of the club members then serving in the military. The young women are, clockwise from upper left, Ramona Marz Hoppe, Rosemarie Berger Trimpe Lortz, Joanna Berger Geiger, and Esther Lou Moser Reihman.

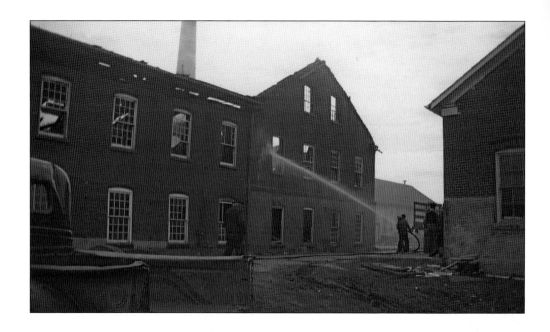

Rudolph Kellenberger was on the scene of the fire at the electrical department and photographed firemen extinguishing the blaze, which had started around 10:00 p.m. the previous night, June 7, 1943. The blaze was fueled by thousands of gallons of paint and paint thinner used in the manufacturing process and lasted for more than six hours. Because the electrical department was working on government contracts, the FBI investigated the blaze. A local man confessed to setting the fire and served time in federal prison for the crime, although he was released early due to questions about his guilt.

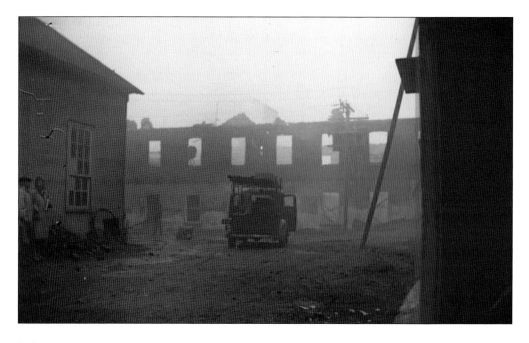

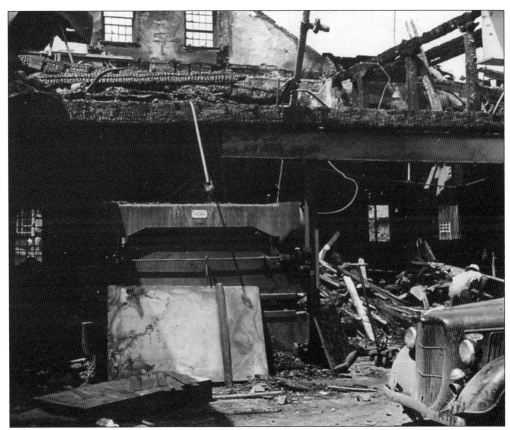

Despite the devastation evident in these photographs of the factory ruins, production of coolers and other units for military contracts continued with little interruption. While the main factory was being rebuilt, employees worked in a variety of different workshop spaces around the seven villages. The loss of the buildings, equipment, and inventory was approximately $250,000.

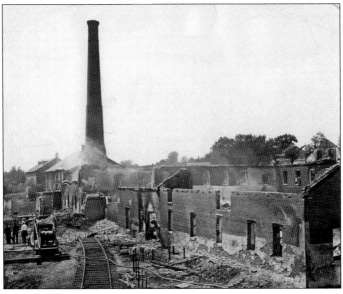

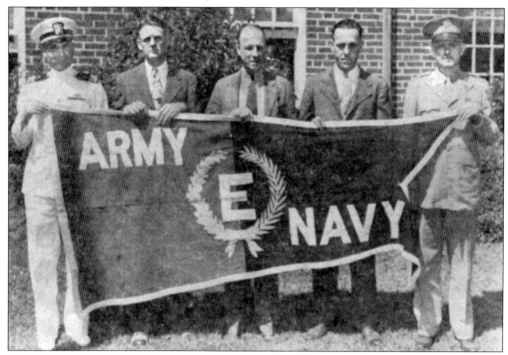

In 1943, the Amana Society received the Army-Navy E Award for excellence in production in its refrigeration division. Military, political, and local figures stand with the award pennant in front of Amana High School auditorium following the award presentation. This photograph appeared in the *Cedar Rapids Gazette* of July 23, 1943, the day after the award ceremony. Pictured are, from left to right, Lt. Comdr. Robert M. Schwyhart (1908–2001), chaplain of the Navy preflight school at Iowa City; George C. Foerstner (1908–2000), division manager; Iowa governor Bourke B. Hickenlooper (1896–1971); Paul H. Oehl (1904–1981), employee; and Lt. Col. Herbert R. Watson, the contracting officer of the Washington quartermaster depot. (Author's collection.)

Wartime contracts for blankets and material for uniforms required fast expansion of the workspace at the Amana Woolen Mill. Here crews build a new dye house, enclosing the original brick dye house within the new concrete block building so that production would not need to be stopped for construction.

The Amana Young Men's Bureau sponsored an honor roll listing all of the Amana men and women serving in the military during World War II. The sign was hand-lettered by John Noé on steel sheets mounted in a wooden frame adjacent to the Amana gas station and dedicated on October 12, 1943. As men enlisted, their names were added. Gold stars were added beside the names of those who lost their lives. Taken down after the war, the original panels were rediscovered in storage in 1992 and are now part of the collection of the Amana Heritage Society.

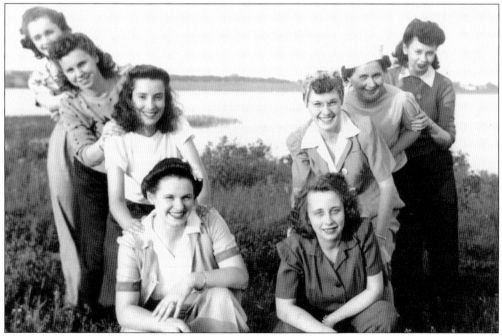

The eight women pictured here are posed as a V for Victory during World War II. All eight of the women had boyfriends or spouses serving in the military at the time. Pictured are, from left to right, Marie Bretschneider Stumpff (1924–2008), Mildred Ackerman Meyer, Dorothy Leichsenring Mittelbach (1924–1985), Elise Oesterle Mattes (1922–2010), Marie Noé Larew (1924–2013), Kathryn Geiger Baumgartel (1918–2000), Marie Stuck Selzer (1916–1999), and Louise Meyer Ackerman (1922–1989). (Author's collection.)

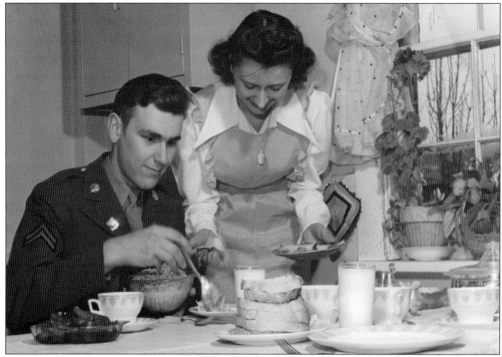

Cpl. Clarence Ehrmann (1919–1975) was home on furlough from his position as a preflight instructor stationed in Wisconsin when he was photographed being served a meal by his wife, Elsie Goerler Ehrmann (1917–1997). Ehrmann eventually achieved the rank of staff sergeant in the Army Air Forces. (Author's collection.)

Members of the Amana Young Men's Bureau dedicated this memorial in 1946 to the memory of the four Amana men who died during World War II. The memorial stood in front of the Amana High School. In 1969, the memorial was relocated to the new high school building and today stands outside the Amana Library. All four men were killed in 1945. Pvt. Oswald Solbrig (1925–1945), Sgt. John H. Eichacker (1910–1945), and Cpl. William Hertel (1922–1945) were Amana natives, while Charles Jensen was employed on the Amana farms.

BIBLIOGRAPHY

Albers, Marjorie K. and Peter Hoehnle. *Amana Style: Furniture, Arts, Crafts, Architecture and Gardens*. Iowa City, IA: Penfield Books, 2005.

Bendorf, Madeline Roemig. *Growing Up in Amana*. Cedar Rapids, IA: Eagle Books, 2013.

Bourret, Joan Liffring-Zug. *The Amanas: A Photographic Journey, 1959–1999*. Iowa City, IA: Penfield Press, 2000.

————. *The Amanas Yesterday: Seven Communal Villages in Iowa*. Iowa City: Penfield Press, 1975.

DuVal, F. Alan. *Christian Metz: German American Religious Leader & Pioneer*. Iowa City, IA: Penfield Books, 2005.

Foerstner, Abigail. *Picturing Utopia: Bertha Shambaugh & the Amana Photographers*. Iowa City, IA: University of Iowa Press, 2000.

Hoehnle, Peter. *The Amana People: The History of a Religious Community*. Iowa City, IA: Penfield Books, 2003.

Hoppe, Emilie Zuber. *Seasons of Plenty: Amana Communal Cooking*. Iowa City, IA: University of Iowa Press, 1998.

Rettig, Lawrence. *Amana Today: A History of the Amana Colonies from 1932 to the Present*. Amana, IA: Amana Society, 1975.

————. *Gardening the Amana Way*. Iowa City, IA: University of Iowa Press, 2013.

Shambaugh, Bertha M.H. *Amana: The Community of True Inspiration*. Iowa City, IA: State Historical Society of Iowa, 1908.

Webber, Philip E. *Kolonie-Deutsche: Life and Language in Amana, An Expanded Edition*. Iowa City, IA: University of Iowa Press, 2009.

Wendler, Glenn H. *The Commune's Last Child*. Amana, IA: North Amana Workshops, 2005.

Yambura, Barbara Selzer and Eunice W. Bodine. *A Change and a Parting: My Story of Amana*. Revised ed. Iowa City, IA: Penfield Press, 2001.